Rabun County

ON THE FRONT COVER: This 1926 photograph of the Derrick Standard Oil Station on Main Street in Clayton was taken shortly after the building was erected. The station was owned by Claude Derrick (who played professional baseball and is in the Georgia Sports Hall of Fame) and his brother Fred Derrick (who also played professional baseball). The Derrick family operated the gas station until 1974, after which it remained vacant for years. The Derrick family sold the building to George Prater in 1986. Prater ran an insurance agency there for years before establishing Prater's Main Street Books. The building features a Spanish red-tile roof, an exposed pebble stucco finish, and an embossed tin ceiling—all of which have been preserved with loving care. (Courtesy of the Georgia Department of Archives and History.)

ON THE BACK COVER: This 1946 Artvue Post Card Co. postcard features campers posing in canoes on Lake Dixie at the Dixie Camp for Girls. The camp was located in the Germany community near Clayton. Lake Dixie provided opportunities for activities such as swimming, fishing, and canoeing. (Courtesy of the authors; published by Artvue Post Card Co., New York.)

POSTCARD HISTORY SERIES

Rabun County

Vickie Leach Prater and George H. Prater

ARCADIA
PUBLISHING

Published by Arcadia Publishing
Charleston, South Carolina

Printed in the United States of America

Library of Congress Control Number: 2012938603

For all general information contact Arcadia Publishing at:
Telephone 843-853-2070
Fax 843-853-0044
E-mail sales@arcadiapublishing.com
For customer service and orders:
Toll-Free 1-888-313-2665

Visit us on the Internet at www.arcadiapublishing.com

*We would like to dedicate this book to the people of Rabun County
who we are blessed to call family, friends, and neighbors.*

CONTENTS

ACKNOWLEDGMENTS

We would like to acknowledge and thank the Rabun County Historical Society and the Foxfire Fund Incorporated for preserving the history of the county and her people.

The Rabun County Historical Society has worked diligently for years to obtain, preserve, and display historical artifacts from around the county. The society's museum, located on Church Street in Clayton, is entirely staffed by volunteers and features ever-evolving historical exhibits. The society maintains a website with links to historical pictures with captions and publishes *Sketches of Rabun County History* so it remains in print for those seeking to read more about the county's early history.

The Foxfire program began in 1966 as an English teacher's effort to get students involved in their education and the history and culture of their regions. Foxfire was the beginning of a national grassroots movement of "cultural journalism." For over four decades now, high school students have embarked on a mission to interview older community residents and document the skills, traditions, experiences, and history of the Appalachian culture. Foxfire also operates a museum tucked away on a mountainside in Mountain City, Georgia, where visitors can experience homes, tools, trades, crafts, and the lifestyle of pioneer culture in the Southern Appalachians.

Unless otherwise noted, all of the images in this book are courtesy of the authors. Following each caption, in parentheses, is information about the postcard publisher. The authors hope to allow the images to tell the story of Rabun County as seen through the eyes of those who made, bought, sold, traded, and saved the cards.

INTRODUCTION

The northeast corner of Georgia is a region of fertile valleys, wooded mountains, abundant water sources, and diversified wildlife. The early inhabitants, mostly Cherokee, grew crops, hunted game, and built communities, including the famous ancient town of Sitcoe (the present-day location of the city of Clayton). In the early 1700s, white men began exploring the area. One such explorer was the famous botanist William Bartram, who collected plant specimens and wrote detailed journals of his discoveries. Bartram wrote this about his life's work: "I am continually impelled by a restless spirit of curiosity in pursuit of new productions of nature, my chief happiness consists in tracing and admiring the infinite power, majesty, and perfection of the great almighty Creator, and in the contemplation, that through divine aid and permission, I might be instrumental in discovering, and introducing into my native country, some original productions of nature, which might become useful to society." Today, thousands of hikers each year retrace the naturalist's footsteps along the Bartram Trail.

In the 1800s, the influx of white settlers to Georgia and their desire for more land led to the treaties of 1817 and 1819, which ceded Cherokee lands to the State of Georgia. In 1819, the Georgia General Assembly passed an act establishing Rabun County, which it named after William Rabun, the 11th governor of Georgia, who died in office that same year. In 1820, the state sent five teams to survey the newly acquired land, dividing it into five districts. The state then began the process of legally settling the county via a "land lottery" for the citizens of Georgia.

People who won original land lots soon found that although they lived in one of the most beautiful places in the world, life as a mountain settler was harsh. Travel and trade was difficult, as few roads existed. A common refrain among those who lived there was "make do or do without." People became self-sufficient by growing corn and other crops to feed their families and their livestock. They hunted, fished, and even built homes from the natural resources that surrounded them. Throughout the county, small local communities formed where people could barter and socialize.

In 1882, the Tallulah Falls Railroad reached the county's southern border, and with it came more people and opportunities. Around Tallulah Falls, hotels and boardinghouses sprung up to meet the demand to accommodate the growing crowds. Tourists bravely descended into the 1,000-foot chasm known as Tallulah Gorge. There, they viewed thunderous waterfalls formed by the Tallulah River as it continued to carve a path along the rocky bottom of the gorge. Entire families came to spend the summer to escape the heat and for protection from diseases, such as malaria, that were prevalent in cities south. The railroad reached Clayton in 1904 and Franklin, North Carolina, in 1907. The completed railroad connected the south end of the county to the north, providing

a means to trade goods and services. Increased trading opportunities improved the economic viability of the county, and residents saw their standards of living rise.

The start of the 20th century marked improved modes of transportation and modern technology throughout Georgia creating an increasing demand for electric power. Rabun County's valuable water supply was selected to provide electricity for the growing demands of Atlanta, the home of the state capital. From 1911 through 1927, the Georgia Railway and Power Company built a series of hydroelectric dams harnessing the power of the Tallulah River. The damming of the river diminished the grandeur of the waterfalls in the gorge, and the number of visitors began to decline; however, the lakes formed from the dams became home to tens of thousands of local and seasonal homeowners.

Rabun County contains nearly 155,000 acres of the Chattahoochee National Forest, which was established in 1911 through the purchase of old homesteads and abandoned farm land. Rabun County is home to three state parks: Black Rock Mountain State Park, Moccasin Creek State Park, and Tallulah Gorge State Park. Every summer, the population swells as heat drives people to the mountains in search of cool getaways; this inspired the county motto—"Where Spring Spends the Summer."

Since the early 20th century, postcards have documented and preserved the social histories of communities all over the world, and Rabun County is no exception.

In the United States, the first souvenir or "picture" postcards were created in 1893 for the World's Columbian Exposition in Chicago. Starting in 1898, American publishers were allowed to print and sell cards bearing the inscription, "Private Mailing Card, Authorized by Act of Congress on May 19, 1898." These private mailing cards were to be posted with 1¢ stamps, only addresses could be written on the back, and written messages were limited to the front (picture side) of the cards. In 1901, the federal government granted the use of the words "Post Card," to be printed on the privately made cards, and allowed publishers to drop the authorization inscription. Written messages were still limited to the front side of the cards, which is why early postcards often have writing on and around the picture.

In 1907, the US Congress finally passed laws that allowed both addresses and messages to be written on the back of postcards, leaving the front images unblemished. These changes ushered in the "golden age" of postcard collecting, when millions of cards were posted, and almost everyone had an album full of personal collections. Postcard trading was an international activity, with publications dedicated to matching up pen pals. Postcards were published and sold by almost every local drugstore, photographer, and tourist destination. Two world wars, an economic depression, and new forms of entertainment ended the postcard craze. Thanks to early collectors and their descendants, images of long-gone buildings, people, and events have been preserved for future generations.

One

FACES OF
RABUN COUNTY

Early settlers in Rabun County were made of strong pioneer stock. Roads were few and travel was hard, which meant isolation for most families; they needed to produce their own food, clothes, and shelter from what the land could provide. Entire families worked from "can see to can't see" just to survive. Fathers and mothers passed down knowledge about how to hunt, fish, farm, build, cook, and sew. Today's youth still record, through the Foxfire series, the oral histories of their elders, helping to preserve the knowledge, traditions, and values of prior generations.

Descendants of the early settlers witnessed the building of railroads and hydroelectric dams; they saw telephone and electric lines strung across the mountains. As the years passed, transportation improved, communities grew, schools were built, and economies flourished. The people modernized their lives, and children—including Logan E. Bleckley, Claude Derrick, and Lillian Smith—received educations that would allow them to make their marks on history.

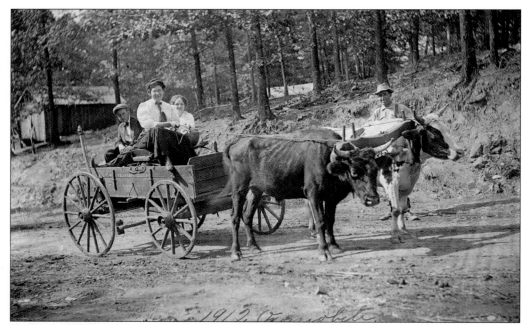

OXCART, TALLULAH FALLS. At the end of the 19th century, ox-pulled carts and wagons were common sights on the dirt roads of the Georgia mountains. This 1912 postcard, postmarked Tallulah Falls, shows a two-ox team pulling a wagon with a woman at the reins. The wagon is identified on the side as a Clarkesville, Georgia, hackney coach.

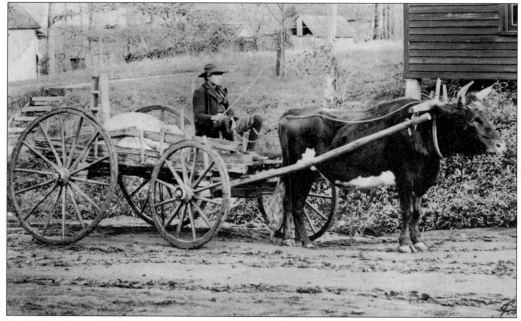

GEORGIA OXCART, RABUN COUNTY. "You can see how they automobile in the mtns. About as good as driving old Dave," reads the message on the back of this 1911 postcard postmarked from Demorest. Travel through the mountains often meant walking, horseback riding, or utilizing an oxcart. Oxen were not only used for travel; they were essential parts of the animal labor required to build the county.

BAL DOCKINS, TALLULAH FALLS.
This picture shows Bal Dockins, from Clayton, and an unidentified group of women in the gorge. This photograph—along with several others from that day—was taken by photographer Walter Hunnicutt in 1910. Hunnicutt captured thousands of vivid images in the early 1900s and published a great many postcards from around the county. (Walter Hunnicutt, Tallulah Falls.)

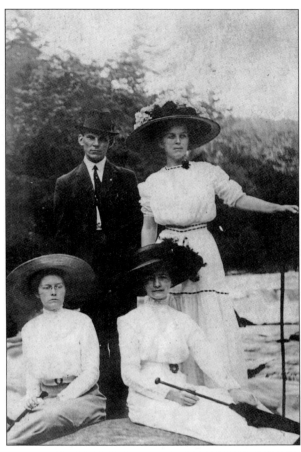

WALTER HUNNICUTT, TALLULAH FALLS. Walter Hunnicutt is the photographer and/or publisher of many of the postcards in this book. This postcard is one he sent in 1909 to a subject that he photographed. He wrote: "Your pictures have been sent to Ashville [*sic*], N.C. & you will have to send postage to the post master there & he will forward them to you." (Walter Hunnicutt, Tallulah Falls.)

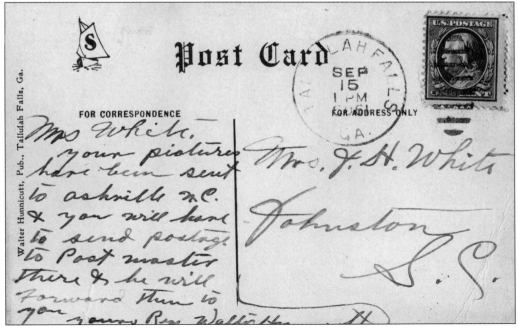

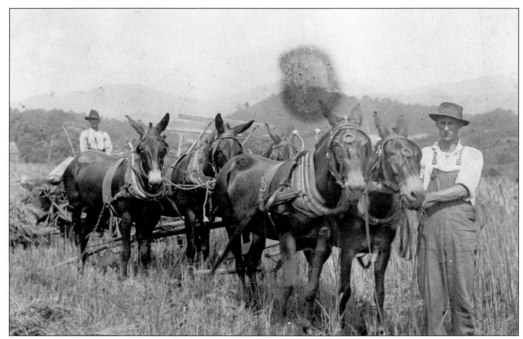

FARMING SCENE, DILLARD. These farmers are threshing grain with a four-mule team in the fertile valleys of northeast Georgia. On the back of this c. 1910 postcard is a handwritten notation indicating that this is a photograph of "Uncle John and Frank Dillard." The valleys around Dillard still contain prime agricultural land.

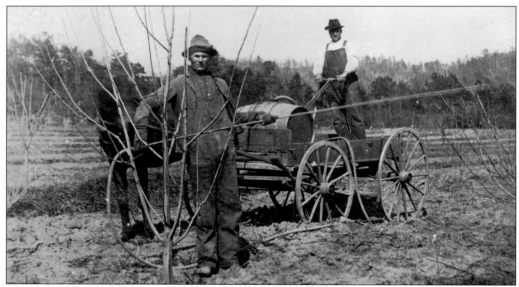

APPLE ORCHARD, RABUN COUNTY. This postcard shows an unidentified man in the back of a horse-drawn wagon pumping spray from a wooden barrel as the farmer on the ground sprays apple trees with a wand. Around 1910, when this postcard was made, apples became a major crop for farmers in the county, and many large orchards were planted. Rabun County is still a prime growing area for delicious Georgia apples.

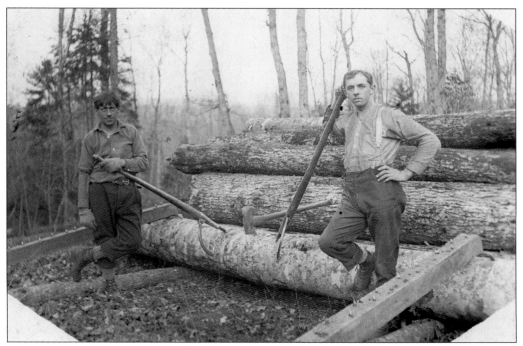

LOGGING, RABUN COUNTY. Logging was once one of the main occupations in the mountains. The two men shown in this c. 1910 postcard are using beams to help stack huge logs. The construction of the railroad required a lot of lumber, and trains later facilitated the logging trade by enabling the transport of timber to buyers in other areas.

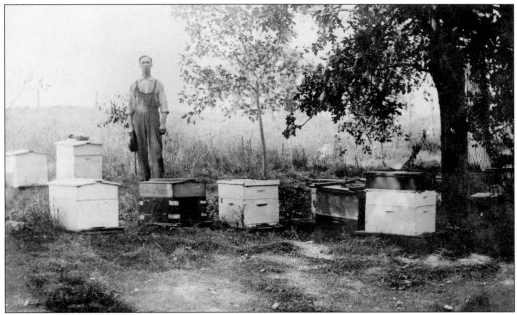

BEEKEEPING, RABUN COUNTY. Beekeepers in Rabun County have produced wonderful honey for generations. The abundant wildflowers in the area provide great foraging for the bees, but it is the blooms of local sourwood trees that yield the delicate, light-colored honey treasured by locals and visitors. This c. 1910 card shows a beekeeper with several hives.

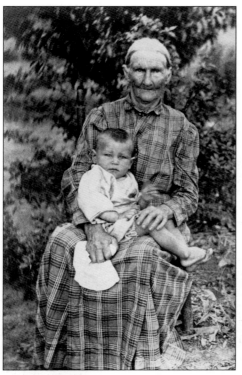

OLD WOMAN, RABUN COUNTY. Traveling photographers took candid photographs of people and events, developing the images as they went and selling the pictures. This c. 1910 image of an unidentified woman and child, from a Rabun County family collection, captures the essence of the rural mountain people.

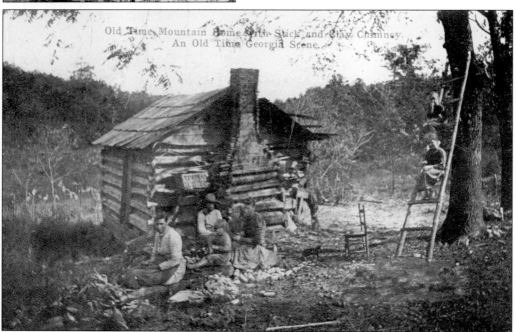

Old Time Mountain Home with Stick and Clay Chimney. An Old Time Georgia Scene.

LOG CABIN, RABUN COUNTY. The stick-and-clay chimney on this cabin was of the type typically found on the early dwellings of the poorest settlers, who built their own homes from the natural elements on their land. Generally, such cabins were constructed with one room and added to as the family could afford it. A close look reveals this family shucking corn. (Blue Ridge Mountain Postcard Co., Tallulah Falls.)

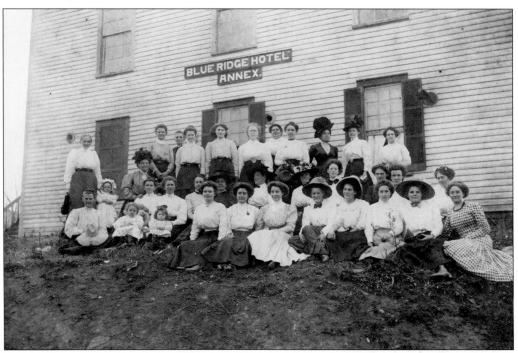

BLUE RIDGE HOTEL ANNEX, CLAYTON. This is not a postcard but rather an original picture taken by an unidentified photographer. This group of women and girls gathered near the back of the Blue Ridge Hotel Annex, which was located on Main Street in Clayton. The group appears to be the founders of the Clayton Women's Club.

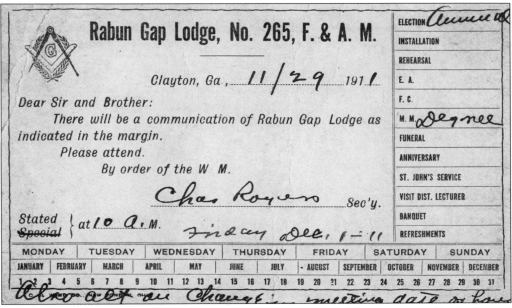

MASONS MEETING, RABUN GAP. This meeting notice was mailed from secretary Charles Rogers to member B.T. (Bal) Dockins in November 1911. The Rabun Gap Lodge received its charter in 1867 and is still active today. (Rabun Gap Lodge.)

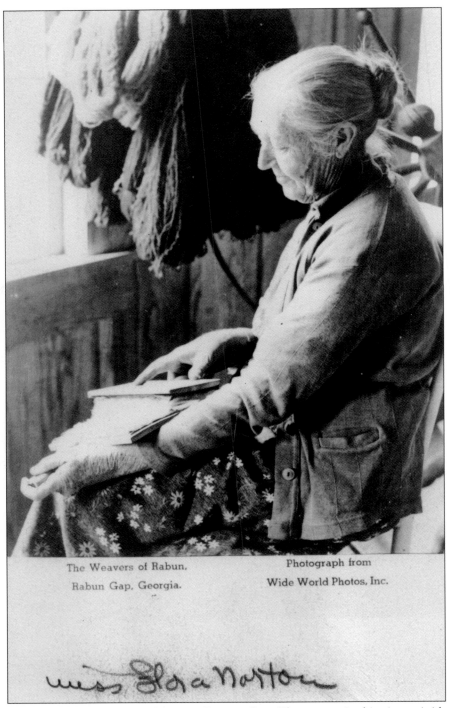

The Weavers of Rabun.
Rabun Gap, Georgia.

Photograph from
Wide World Photos, Inc.

miss Flora Norton

CARDING WOOL AT HAMBIDGE CENTER, RABUN GAP. The woman in this picture is identified as "Miss Flora Norton" by the handwritten notation at the bottom of the card. Carding wool involves brushing wool between two hand cards so that the fiber is straightened and aligned. In 1947, the "Weavers of Rabun" were commissioned to produce all the fabric for Pres. Harry Truman's yacht. (World Wide Photos, Inc.)

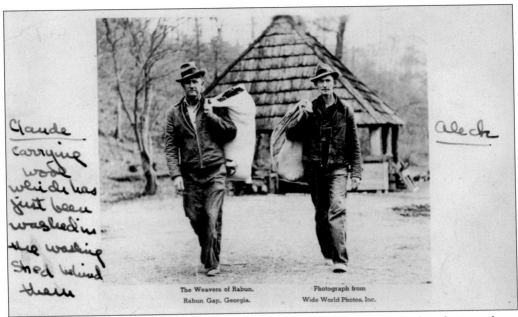

Claude carrying wool which has just been washed in the washing shed behind them

Aleck

The Weavers of Rabun.
Rabun Gap, Georgia.

Photograph from
Wide World Photos, Inc.

WASHING SHED AT HAMBIDGE CENTER, RABUN GAP. The two men in this photograph are identified in handwritten notation as Claude (left) and Aleck. The men are carrying wool that has just been washed in the washing shed behind them. In 1934, Mary Crovatt Hambidge started the farm cooperative and helped refine the spinning and weaving talents of local women. (World Wide Photos, Inc.)

THE WEAVERS OF RABUN, RABUN GAP. The Weavers of Rabun gained international fame in the 1940s and 1950s as their fabrics were sold on posh Madison Avenue in New York City. In this photograph, women are holding fabrics, a spinning wheel is on the porch, and two men are leading a calf. The Hambidge Center now hosts retreats for artisans and writers. (World Wide Photos, Inc.)

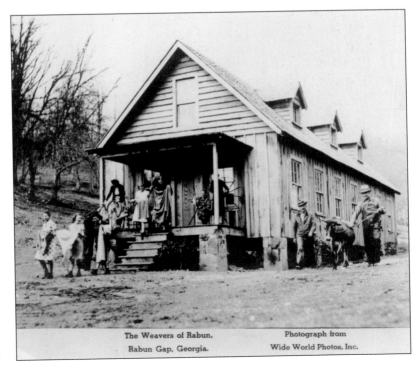

The Weavers of Rabun,
Rabun Gap, Georgia.

Photograph from
Wide World Photos, Inc.

17

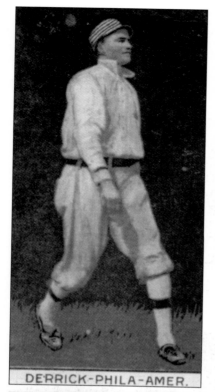

DERRICK-PHILA-AMER.

CLAUDE DERRICK AND THE BABE. The back of the original 1910 baseball card at left says, "Claude Derrick, utility infielder on the Athletics, is a product of Georgia College. His first work was with the Georgia Tech team in 1907. In 1908 he played first for Georgia and in 1909 was a member of the Greenville, SC team of the Carolina Association. Harry Davis discovered his talent that season and tipped him off to Manager Mack. He reported to the Athletics in 1910 and made good at once. Last season he batted .230 and fielded .960 at first and second, where he was used for utility work." In 1912, Derrick broke his ankle and was sent to Baltimore, where his roommate was a rookie named Babe Ruth, pictured below in the backseat of the automobile with Claude (left) and his brother Fred Derrick in the front. Claude was born in Burton, Georgia, in 1886; he died in 1974 at the age of 88 and is buried in Clayton. (Left, published by Recruit Little Cigars; below, courtesy of the Derrick family.)

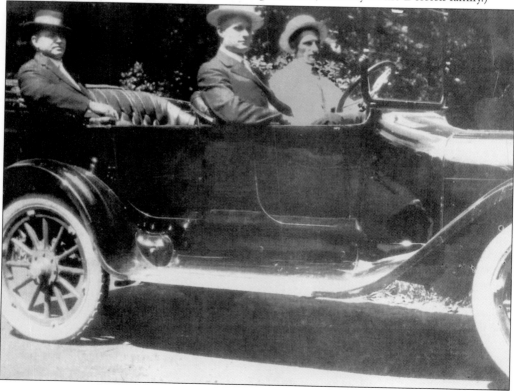

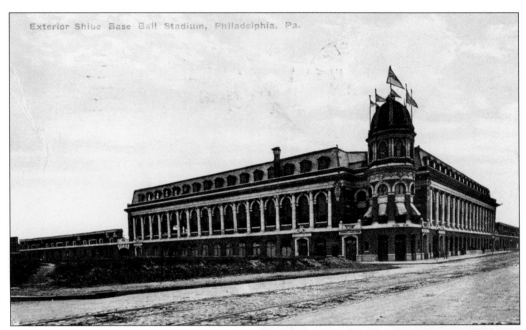

Exterior Shibe Base Ball Stadium, Philadelphia, Pa.

CLAUDE DERRICK IN PHILADELPHIA. The postcard above shows Shibe Park, the stadium where Georgia Sports Hall of Famer Claude Derrick played professional baseball for the Philadelphia Athletics. Derrick, Georgia's first "big-league" baseball player, also played for the New York Yankees and in Baltimore, Indianapolis, and Toledo. In the postcard, sent from Derrick to Bal Dockins, he wrote, "It is raining and there is no hope for a game today . . . I know you are looking forward to the summer when the pretty girls will be up in Clayton in droves." After serving in the military during World War I, Derrick returned to Clayton and built the Standard Oil Station on Main Street. The station, which still stands, has been renovated and now houses Prater's Main Street Books. (Above, published by Souva Chrome Postcard Co.; right, courtesy of the Derrick family.)

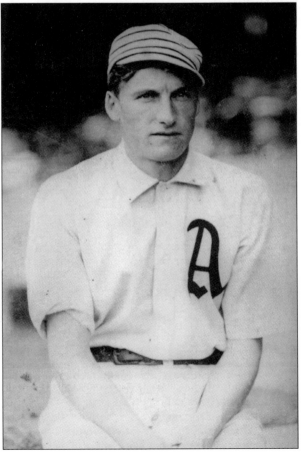

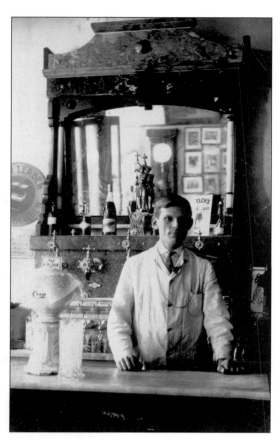

BALLENGER T. DOCKINS (1881–1957).
This c. 1910 photograph shows Ballenger T.
(Bal) Dockins working behind the counter
as a soda jerk at the Dover and Green
Drug Store. Pictured here are a beautiful
porcelain Coca-Cola dispenser, Welch's
grape juice bottles, and a tobacco sign.
Dover and Green Drug Store was located
on Main Street in Clayton.

HIKE TO TALLULAH FALLS. Dockins and three
unidentified women pose for a picture taken by
Walter Hunnicutt around 1910. The foursome
hiked down into the gorge using hiking sticks
and stood before the rock formation known as
Witch's Head. (Walter Hunnicutt, Tallulah Falls.)

BAL DOCKINS, TALLULAH FALLS.
Dockins posed alone for this photograph, taken the same day as the outing shown on the previous page. Sometimes, pictures like this that caught odd reflections of light were called "ghost images" because of their otherworldly appearance. (Walter Hunnicutt, Tallulah Falls.)

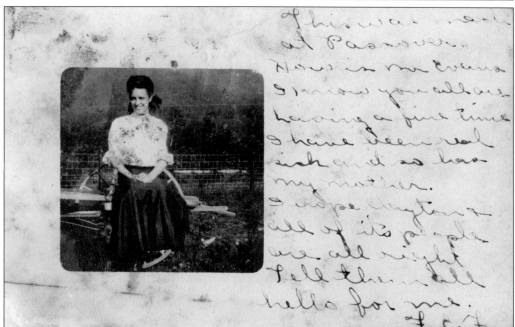

YOUNG WOMAN, PASSOVER. In a postcard mailed to Bal Dockins in 1907, the young lady in the photograph writes "This was made at Passover." Passover was the original name for Mountain City. The sender simply signed her name F.C.F.

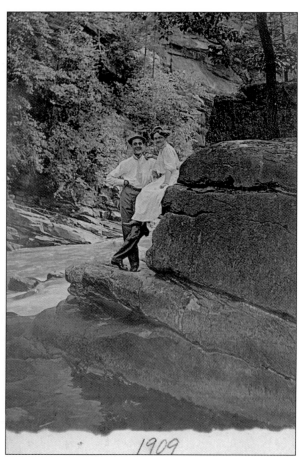

COUPLE, TALLULAH FALLS. An adventurous young couple poses in 1909 on the stair-step rock formation that was one of the area's most popular spots for photographs. The Tallulah River rushed by just past their feet. (Walter Hunnicutt, Tallulah Falls.)

CHAPMAN SERVICE STATION, MOUNTAIN CITY. This 1942 postcard shows the Chapman Service Station, with its gas pumps and numerous advertising signs. The gas station was located on State Highway 23 in Mountain City. It offered free air, Quaker State oil, Coca-Cola, and Camel cigarettes, according to the signs. A man stands just outside the office door at left. (Auburn Greeting Card Co., Auburn.)

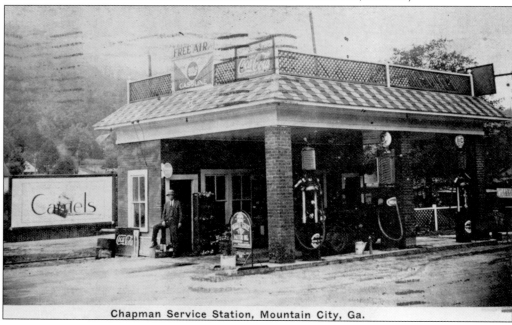

Chapman Service Station, Mountain City, Ga.

Two

RAILROAD EXPANSION

In 1882, the first rail service, the Blue Ridge and Atlantic Railroad, from Cornelia, Georgia, to Rabun County reached the southernmost border at Tallulah Falls. The passenger train service brought a multitude of visitors wanting see the gorge, hike to the waterfalls, and be refreshed in the cool mountain climate. This influx of people created a need for lodging, and thus began the resort era of Tallulah Falls. In 1898, the line from Cornelia to Tallulah Falls was purchased by the Tallulah Falls Railway Company, which then expanded the line through the heart of Rabun County to Franklin, North Carolina.

The railroad reached the county seat (Clayton) in 1904 and finally reached Franklin in 1907. Regular passenger stops started at Tallulah Lodge and continued north, stopping at Tallulah Falls, Lakemont, Wiley, Tiger, Clayton, Mountain City, Rabun Gap, and Dillard. There were other places along the way, such as Joy and Bethel, where the train would stop if flagged. The construction of the train brought workers to the area, provided jobs for many locals, and opened up the entire county for economic expansion in the early 1900s.

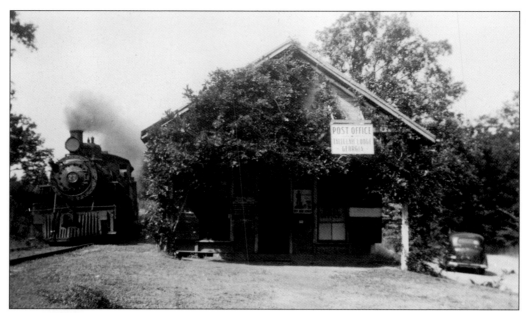

POST OFFICE DEPOT, TALLULAH LODGE. Tallulah Lodge lies in Habersham County, along the gorge. This passenger stop was located about a mile south of Tallulah Falls and provided access for travelers to the Tallulah Lodge hotel. The post office survived until the 1960s, after the railroad was shut down. In this 1940s image, there is a World War II "Buy War Bonds" poster in the window.

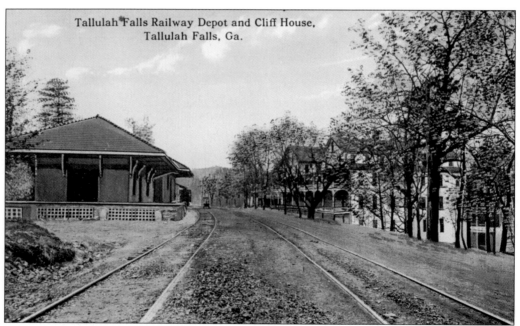

RAILWAY DEPOT AND CLIFF HOUSE, TALLULAH FALLS. This c. 1907 postcard shows the new Tallulah Falls Railway depot, with its beautiful red-tile roof. Across the street is the famous Cliff House hotel. The depot building survived a 1921 fire and remains in good condition today; it has housed several businesses since train service was discontinued in the 1960s. (Curt Teich Company, Chicago.)

24

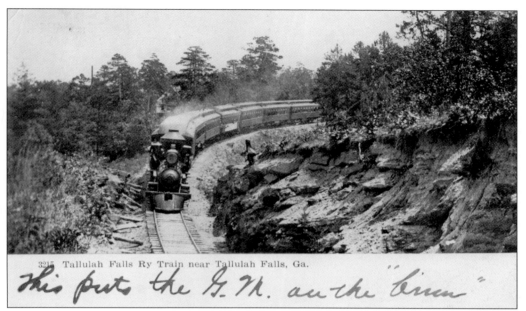

3215 Tallulah Falls Ry Train near Tallulah Falls, Ga.

This puts the G. M. on the "bum"

TALLULAH FALLS RAILWAY TRAIN. This early 1900s postcard shows a train on the Tallulah Falls Railroad as it comes around a curve heading toward Tallulah Falls. The train's passenger service facilitated travel to the falls and gorge for thousands of tourists from Atlanta and beyond.

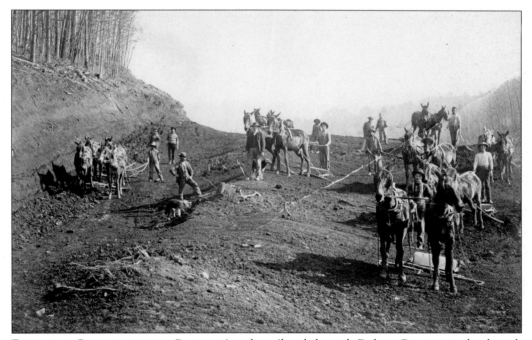

RAILROAD CONSTRUCTION. Constructing the railroad through Rabun County was hard work for man and beast. Land had to be cleared and leveled, which meant horse and mule teams doing the bulk of the labor, as seen in this c. 1910 image.

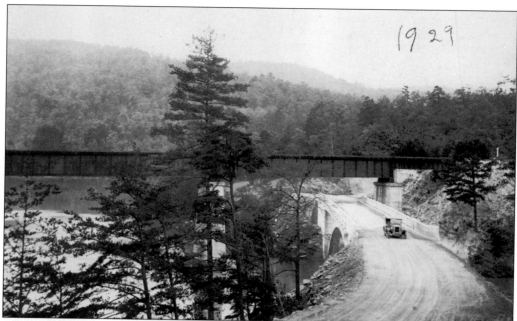

RAILROAD BRIDGE, TALLULAH FALLS. Upon leaving the Tallulah Falls depot, the train had to cross the Tallulah River on a wooden truss-style bridge. As the new dam was nearing completion in 1913, the bridge had to be replaced with a taller concrete and steel structure. This photograph shows the bridge as it appeared in 1929. All that remains today are the concrete pillars in the water.

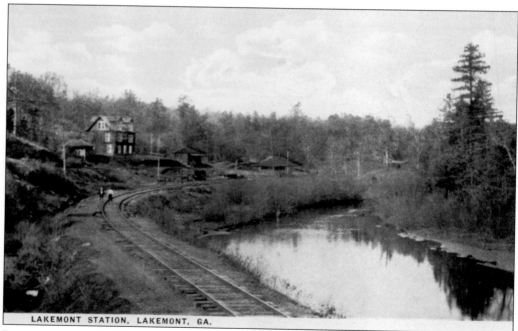

LAKEMONT STATION, LAKEMONT, GA.

LAKEMONT STATION, LAKEMONT. The train depot for Lakemont was seven miles north of Tallulah Falls. The depot was located on Main Street between the Tallulah River and Alley's Store. This c. 1920 postcard shows the depot, store, and river. The depot was removed after passenger service ended in the 1960s. (Smith Bros. & Co., Lakemont.)

MATHIS CUT, LAKEMONT. The Mathis Cut, pictured on this postcard, was five miles north of Tallulah Falls. The Mathis Cut was required for the railroad to travel from Tallulah Falls to the Lakemont Depot. To get an idea as to the magnitude of this cut, look closely at the comparative size of the two men standing in the center of the tracks.

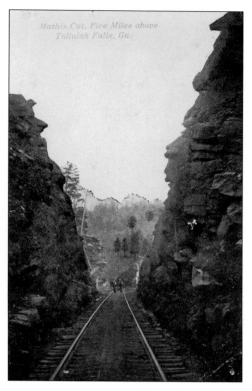

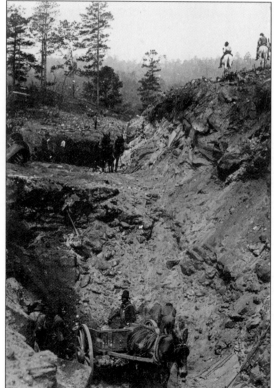

WORKING ON THE RAILROAD. Often, the only way to reduce the grade of the land so that trains could run was to blast through the mountains to create railway cuts. As seen in this c. 1910 postcard, horses, mules, and oxen were often used to pull carts carrying the dirt and rocks from the cuts scattered throughout Rabun County.

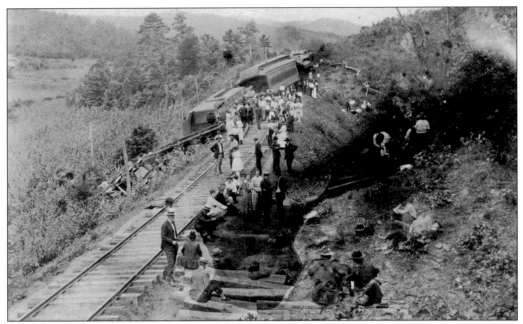

TRAIN WRECK, TIGER. On August 23, 1920, a train carrying girls bound for summer camp derailed between Wiley and Tiger. None of the girls were injured, but the engineer, John Harvey, was killed. The engine and baggage car was overturned in a ditch, and the passenger cars were jumbled around, as shown in this image. The passengers stood or sat outside awaiting help.

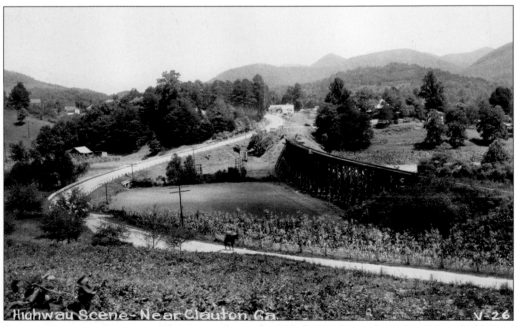

SOUTH TRESTLE, CLAYTON. This image shows the 512-foot train trestle to the right of Old State Highway 441 as it crosses Scott's Creek and heads into Clayton. At the top of the hill is a building with a Sinclair sign, and a mule is walking down the road next to a cornfield near the present-day location of Duval Street. (W.M. Cline Company, Chattanooga.)

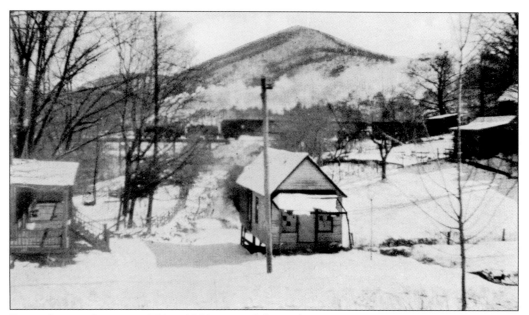

SNOW SCENE, CLAYTON. This c. 1920 postcard shows the train as it passed Clayton heading north after a snowstorm. In the foreground are a house and several other structures; in the background is Screamer Mountain. (Dover and Green, Clayton.)

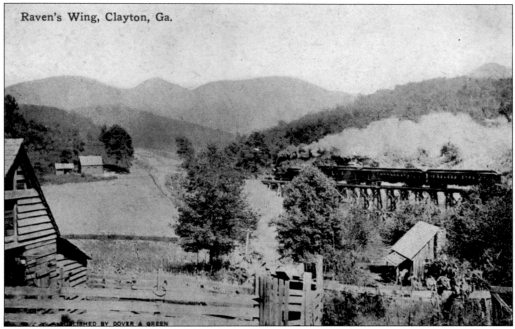

Raven's Wing, Clayton, Ga.

NORTH TRESTLE, CLAYTON. North of Clayton there was another train trestle, shown here with a train heading north. This trestle was not as high or as long as the south trestle. To the left is a barn, and to the right is a small house. At the top is the mountain range known as Raven's Wing. (Dover and Green, Clayton.)

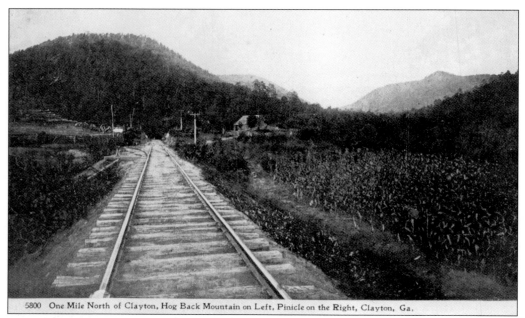

TRAVELING NORTH, CLAYTON. This c. 1907 postcard continues to follow the train tracks northward. This view is from one mile north of Clayton; it shows Pinnacle Mountain on the right and Hog Back Mountain on the left. The title on this card misspells Pinnacle as "Pinicle"—such misspellings were fairly common on postcards. (Walter Hunnicutt, Tallulah Falls.)

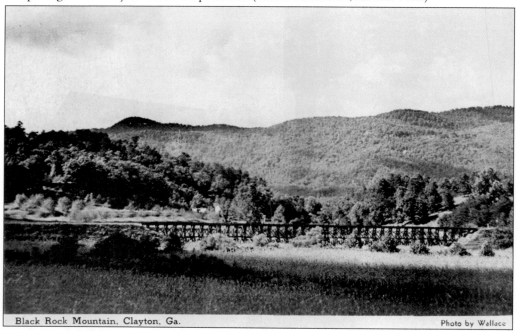

ANOTHER VIEW OF THE NORTH TRESTLE. This 1940s postcard shows another view of the 262-foot north trestle and gives a better idea of its span. This picture was taken from the east side of the tracks, looking toward Black Rock Mountain. The Tallulah Falls Railway had 42 wooden trestles across a 58-mile stretch between Cornelia, Georgia, and Franklin, North Carolina. (Foto Seal Co., New York.)

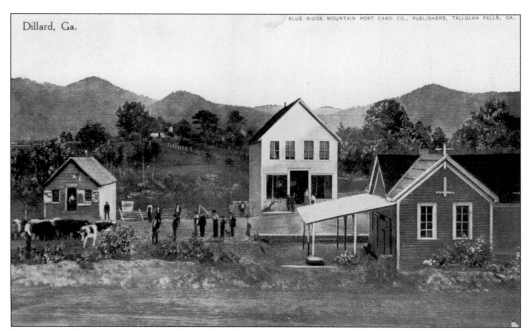

Dillard, Ga.

DILLARD, GEORGIA. Dillard is located in the Little Tennessee River valley and surrounded by the Blue Ridge Mountains. In 1907, the railroad came to Dillard. The depot (right) is visible in this image, as well as a drugstore (left) with a Cardui sign. Cardui was a 38-proof patent medicine for "female problems" that was patented in Chattanooga. The Powell House is also visible (center). (Blue Ridge Mountain Postcard Co., Tallulah Falls.)

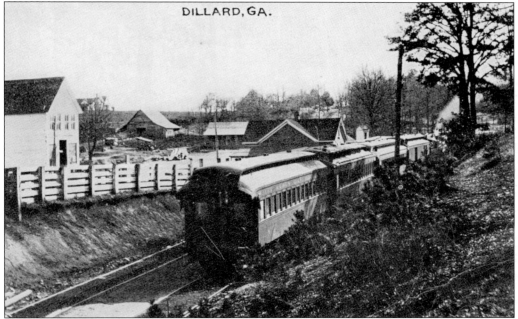

DILLARD, GA.

TRAIN ENTERING DILLARD. This 1916 postcard shows the Tallulah Falls Railway train pulling up to the depot. Dillard was the last regular passenger stop in Georgia before the train continued on to Franklin, North Carolina. Around the time this was taken, judging by the big barn in the background, the town was still mostly agricultural. (W.L. McCoy, Dillard.)

31

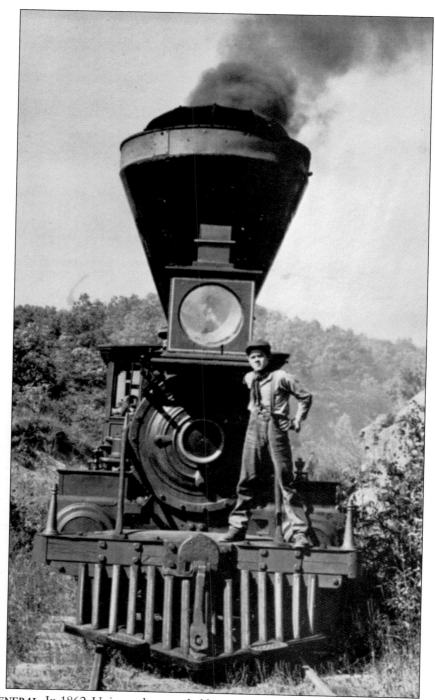

THE *GENERAL*. In 1862, Union volunteers led by James Andrews commandeered the locomotive *General* in Big Shanty, Georgia, and began a run to Chattanooga, Tennessee. The *General*'s conductor, William Fuller, followed in pursuit via foot, handcar, and—finally—the locomotive *Texas*. The *General*, seen here with an unidentified actor, was used in the 1956 movie *The Great Locomotive Chase*, starring Fess Parker; Disney used the Tallulah Falls Railway (and the city of Clayton) while filming. (National Railway Historical Society, Atlanta.)

Three

LODGINGS

The arrival of the railroad and the building of the hydroelectric dams created a need for hotels and boardinghouses for both visitors and workers. Entrepreneurs built grand resorts surrounding Tallulah Falls, opened hotels, and turned homes throughout the county into boardinghouses. According to *Foxfire 10,* a glance through advertisements in back issues of the *Clayton Tribune* reveals that Rabun County once had almost 60 inns and boardinghouses. Fire was the main culprit in the loss of many hotels, including the great 1921 fire at Tallulah Falls that almost destroyed the entire town.

Summer homes gradually replaced boardinghouses around the man-made lakes and on the mountaintops. The railroad was abandoned in the early 1960s, and a new State Highway 441 bypassed many areas, leaving small hotels without guests. While downtown Clayton once contained numerous hotels, only one remains today, and there are currently no hotels in Tallulah Falls. Several old inns around the county have survived, including the York House, Dillard House, Beechwood Inn, and the Lake Rabun Hotel.

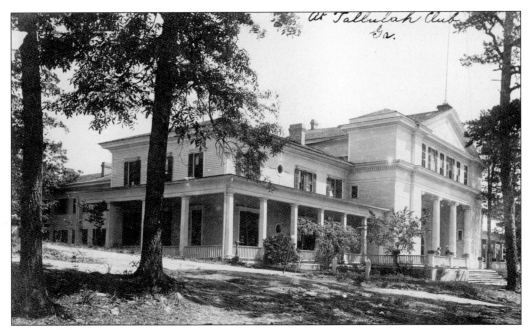

TALLULAH LODGE HOTEL, TALLULAH LODGE. This c. 1910 postcard features the elegant Tallulah Lodge, which catered to the area's most prestigious guests. The train stopped at the Tallulah Lodge post office and depot next to the hotel; this was the first passenger stop at the gorge. The grand hotel offered luxury amenities and activities.

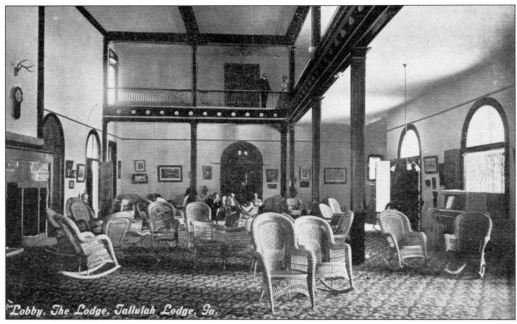

TALLULAH LODGE HOTEL LOBBY. The Tallulah Lodge was built about a mile south of the city of Tallulah. It attracted the wealthiest clientele and boasted an overlook into the gorge known as "Paradise Point." This postcard shows the huge lobby and its wicker rocking chairs. The hotel was destroyed by fire in 1916. (Curt Teich Company, Chicago.)

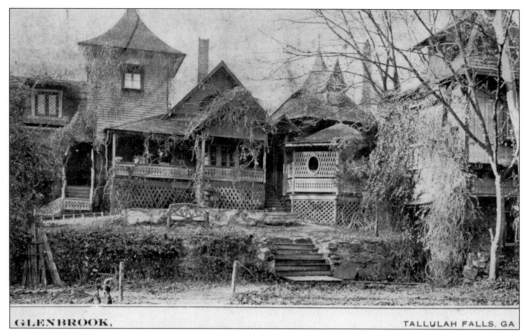

GLENBROOK, TALLULAH FALLS. GA

GLENBROOK COTTAGE, TALLULAH FALLS. This cottage was built in the late 1890s as a private residence but was soon enlarged to become a hotel for tourists who flocked to Tallulah Falls on the new rail line. The hotel was just a short walk up the hill overlooking the train depot and town. The hotel's roofline, with its towers, gables, dormers, and various pitches, dominated the view.

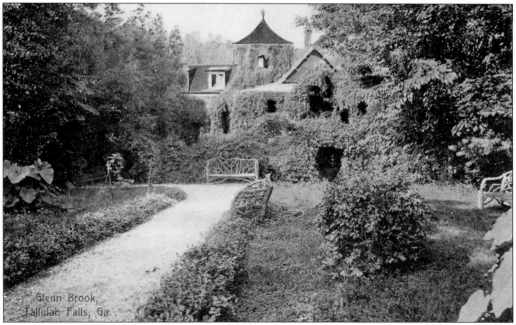

Glenn Brook,
Tallulah Falls, Ga.

GLENBROOK COTTAGE, C. 1911. The Glenbrook Cottage survived the 1921 fire that destroyed much of the city and continued to operate until the 1940s. After reopening for a brief time in the 1950s, the hotel closed for good and was left to rot. Today, only a skeleton of the hotel remains. (F.W. Frye, Tallulah Falls.)

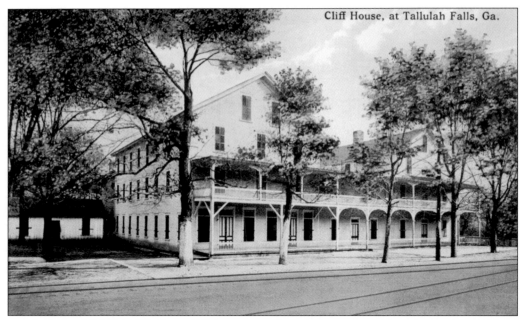

Cliff House, at Tallulah Falls, Ga.

CLIFF HOUSE, C. 1910, TALLULAH FALLS. The Cliff House was built in 1882 by the Moss family, which was from Athens, Georgia. The back of this c. 1910 postcard announces the availability of special Sunday and weekend rates offered by Southern Railway. The Cliff House offered modern conveniences at moderate prices, supported an excellent orchestra during the summer, and could accommodate up to 250 people. (Curt Teich Company, Chicago.)

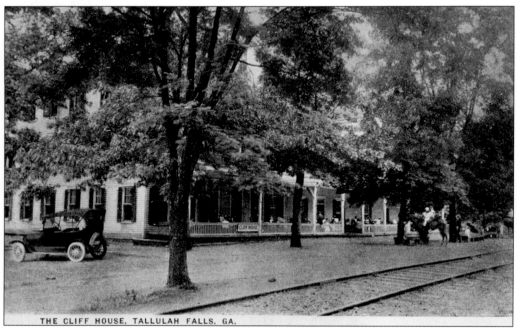

THE CLIFF HOUSE, TALLULAH FALLS, GA.

CLIFF HOUSE, 1920S. A close look at this image shows guests relaxing on the expansive front porch, as well as guests enjoying horseback riding. The great fire of 1921 destroyed most of Tallulah Falls, but the Cliff House survived until 1937. (Commercial Chrome.)

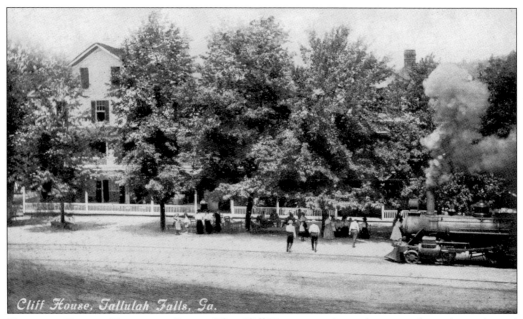

TRAIN IN FRONT, TALLULAH FALLS. The Cliff House was situated next to the train tracks and just across from the depot, making it a favorite stop for travelers. Crowds often formed out front as people gathered to watch the arrival and departure of the trains. (Curt Teich Company, Chicago.)

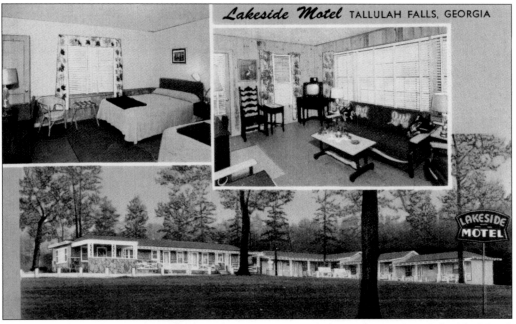

LAKESIDE MOTEL, TALLULAH FALLS. This 1950s postcard shows the modern Lakeside Motel, which overlooked the lake at Tallulah Falls. It was AAA-rated and had air-conditioning, as well as tubs and showers. Mr. and Mrs. D.T. Cannon owned and operated the motel. (Art Tone, Des Moines.)

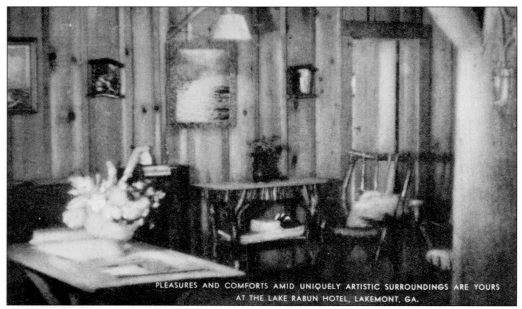

PLEASURES AND COMFORTS AMID UNIQUELY ARTISTIC SURROUNDINGS ARE YOURS AT THE LAKE RABUN HOTEL, LAKEMONT, GA.

LAKE RABUN HOTEL, LAKEMONT. The Lake Rabun Hotel was built in 1922 by Augustus Andreae, a German immigrant. Andreae was in the silk business, but an attempt to raise the worms in North Georgia failed, and he ended up buying land on the shore of the newly created Lake Rabun and opening a hotel. Andreae also started a community organization that preceded the current Lake Rabun Association. (Artvue Post Card Co., New York.)

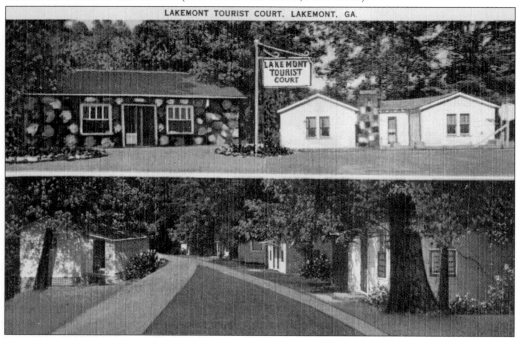

LAKEMONT TOURIST COURT, LAKEMONT, GA.

LAKEMONT TOURIST COURT, LAKEMONT. The Lakemont Tourist Court was located four miles north of Tallulah Falls on US Highway 23. The cottages offered modern Duo-Therm heat and private bathrooms. At the time of this 1940s postcard, Mr. and Mrs. C.M. Arrowood owned the motel. (Henry H. Ahrens, Charlotte.)

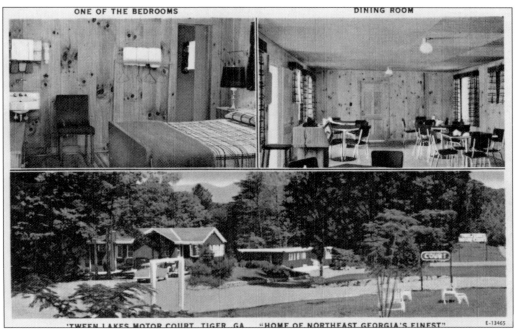

'TWEEN LAKES MOTOR COURT, TIGER. Located three miles south of Clayton, this motel offered 22 modern rooms, a restaurant, and a playground. This 1940s postcard shows the dining room, one of the bedrooms, and the exterior. 'Tween Lake Motor Court—so named because it was located near six lakes—was owned and operated by Mr. and Mrs. Bill Wilson. (Asheville Post Card Co., Asheville.)

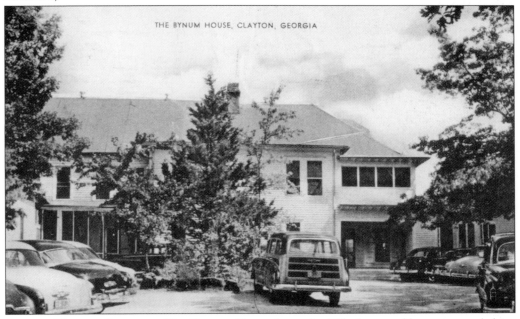

BYNUM HOUSE, CLAYTON. The Bynum House boasted of "fresh vegetables, meats and dairy products from the Bynum House gardens and farm." This 1954 postcard shows a parking lot full of automobiles, including a wonderful old "Woodie" station wagon. The sender of this card wrote, "It's really a wonderful place." (Asheville Post Card Co., Asheville.)

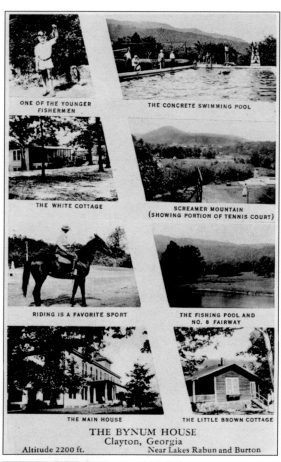

ONE OF THE YOUNGER FISHERMEN

THE CONCRETE SWIMMING POOL

THE WHITE COTTAGE

SCREAMER MOUNTAIN (SHOWING PORTION OF TENNIS COURT)

RIDING IS A FAVORITE SPORT

THE FISHING POOL AND NO. 8 FAIRWAY

THE MAIN HOUSE

THE LITTLE BROWN COTTAGE

THE BYNUM HOUSE
Clayton, Georgia
Altitude 2200 ft. Near Lakes Rabun and Burton

BYNUM HOUSE AMENITIES. "The place to spend a pleasant vacation," was the Bynum House motto. In 1933, the Bynums built the county's first in-ground concrete swimming pool, which they allowed guests and local residents to use free of charge. The Bynums shut down the resort in 1970, and the old house was torn down in 2004. (Conneaut Gravure Co., Conneaut, Ohio.)

"MAIN HOUSE" AT BYNUM HOUSE. The Bynum House was located west of downtown Clayton off of State Highway 76. The Bynums opened their boardinghouse in 1913 and eventually expanded it to include cottages, golf, fishing, and stables. This postcard shows the main house, one of the cottages, visitors enjoying golf and horseback riding, and a view of Raven's Wing. (Asheville Post Card Co., Asheville.)

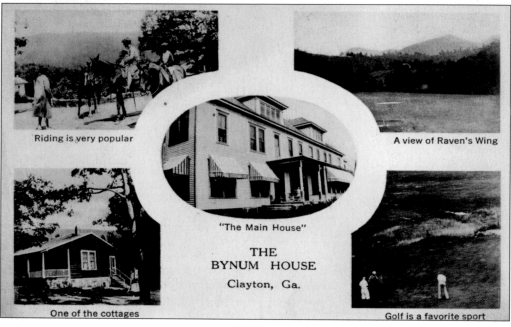

Riding is very popular

A view of Raven's Wing

"The Main House"

THE BYNUM HOUSE
Clayton, Ga.

One of the cottages

Golf is a favorite sport

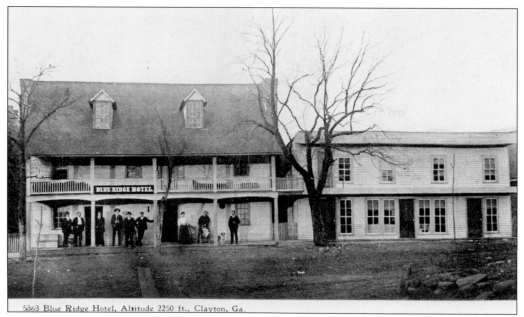

5363 Blue Ridge Hotel, Altitude 2250 ft., Clayton, Ga.

BLUE RIDGE HOTEL, CLAYTON. A.M. Maulding and William Crane built this hotel, located on Main Street, around 1860 for use as a trading post. D.T. Duncan and family operated the hotel for about 30 years, then the hotel passed to Henry Cannon. In 1949, the hotel was torn down. The Cannon family still owns the property, which is now home to the Cannon Furniture store. (Walter Hunnicutt, Tallulah Falls.)

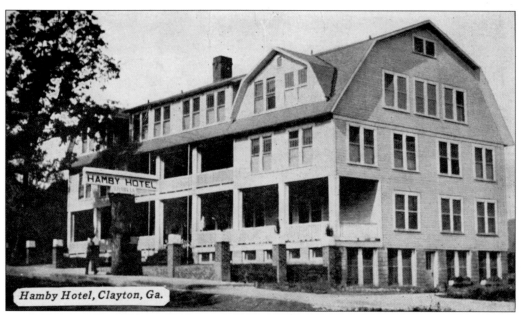

Hamby Hotel, Clayton, Ga.

HAMBY HOTEL, CLAYTON. Built in 1926 on Main Street, the Hamby Hotel offered 50 modern rooms with running water and bathtubs. The hotel was owned and operated by Mrs. R.E.A. Hamby. The hotel boasted that no reservations were necessary—"there is always room for one more." The hotel burned down in 1936. (Hamby Hotel, Clayton.)

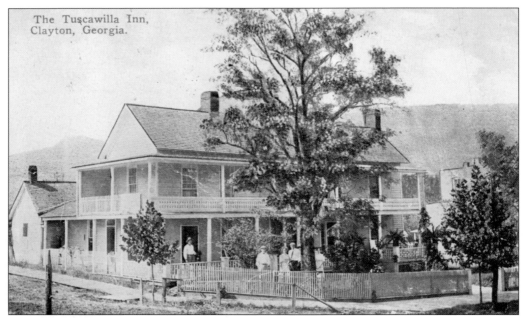

The Tuscawilla Inn,
Clayton, Georgia.

TUSCAWILLA INN, CLAYTON. This postcard shows a group of people in front of the Tuscawilla Inn, a pretty, two-story wooden structure with porches on both floors. Black Rock Mountain is visible in the background, and just to the right of the inn is the upper corner of the Dover and Green Drug Store.

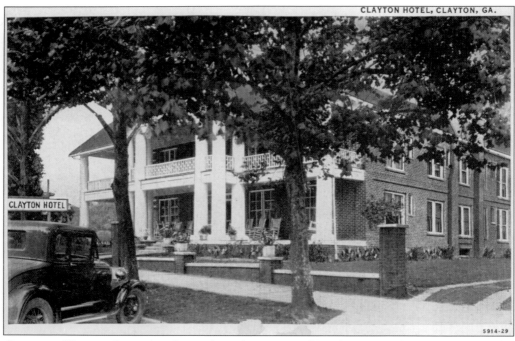

CLAYTON HOTEL, CLAYTON, GA.

CLAYTON HOTEL

5914-29

CLAYTON HOTEL, CLAYTON. Located on the corner of South Main and Derrick Streets, this hotel has a long history. An earlier wood-frame hotel, the Tuscawilla Inn, burned down in this location. This 1930s postcard shows the hotel as a large redbrick building with white columns. Unfortunately, this building also burned to the ground. (Asheville Post Card Co., Asheville.)

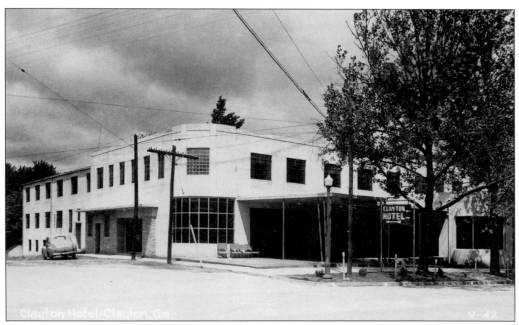

THE NEW CLAYTON HOTEL. After the beautiful redbrick hotel burned, a modern hotel was built in its place. This new building featured Art Deco styling with its curved corners and use of glass brick. This postcard shows the hotel in the 1940s. (W.M. Cline Company, Chattanooga.)

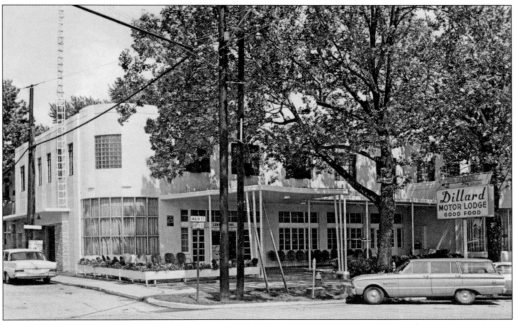

DILLARD MOTOR LODGE, CLAYTON. Around the time that the movie *Deliverance* was being filmed in Rabun County, the Clayton Hotel was owned by a member of the Dillard family, who changed the hotel's name to the Dillard Motor Lodge. Since then, the hotel has been remodeled several times, renamed the Old Clayton Inn, and is now the only hotel on Main Street. (Dexter Press, West Nyack, New York.)

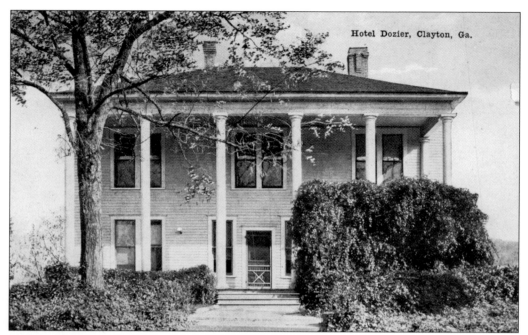

Hotel Dozier, Clayton, Ga.

HOTEL DOZIER, CLAYTON. The Hotel Dozier, pictured on this 1910s postcard, was located on South Main Street opposite the Clayton Hotel and next to the Clayton First United Methodist Church. The Hotel Dozier was later sold to the Green family, who changed the name to the Hotel Green. (E.C. Kropp, Milwaukee.)

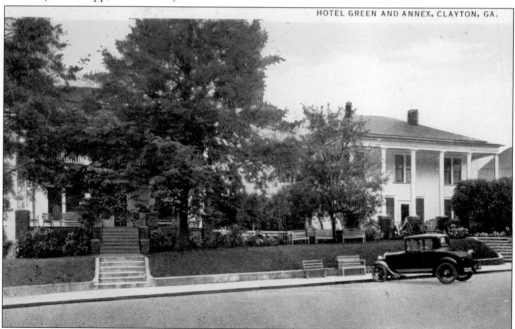

HOTEL GREEN AND ANNEX, CLAYTON, GA.

HOTEL GREEN, CLAYTON. The Hotel Green and Annex are shown in this 1920s postcard. Since that time, both buildings have been torn down. The land where the annex stood was made street level and now houses the Georgia Power office. The land where the hotel stood remains a vacant lot next to the Methodist church. (Asheville Post Card Co., Asheville.)

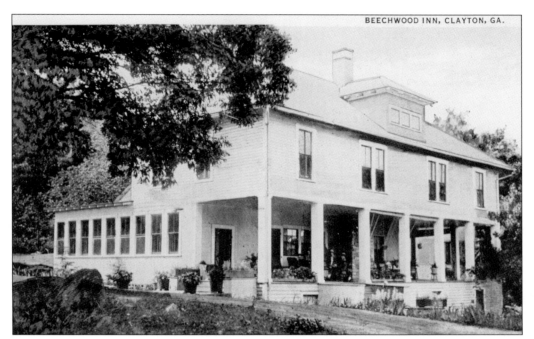

BEECHWOOD INN, CLAYTON. Located off State Highway 76, the Beechwood Inn was built in 1916 as the private home of Dr. Herman Buchholz. In 1922, the family began operating the home as a hotel. The inn was remodeled in 2000, and it is now an award-winning luxury bed and breakfast. (Asheville Post Card Co., Asheville.)

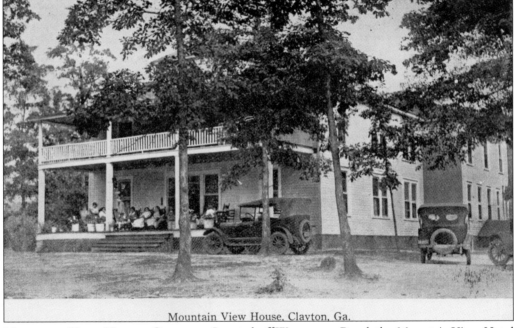

Mountain View House, Clayton, Ga.

MOUNTAIN VIEW HOUSE, CLAYTON. Located off Warwoman Road, the Mountain View Hotel opened in 1916. It was owned and operated by various people. This 1920s postcard lists the owner as T.C. Justus. In 1975, the hotel burned to the ground. Mountain View Health Care is now situated on the property. (Mountain View House, Clayton.)

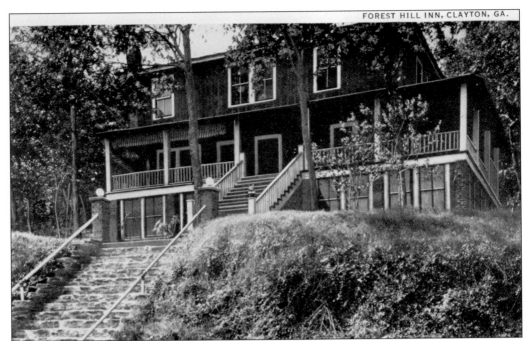

FOREST HILL INN, CLAYTON. The Forest Hill Inn boasted 30 rooms with hot and cold water, a garage, and telephone and telegraph service. The hotel overlooked the highway, railway, valley, and lofty mountain peaks. Brochures advertising the inn said that tubercular patients were not accepted. The inn's proprietor was Bal Dockins. (Asheville Post Card Co., Asheville.)

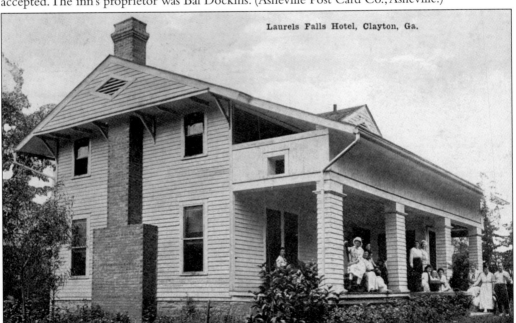

Laurels Falls Hotel, Clayton, Ga.

LAUREL FALLS HOTEL, CLAYTON. C.W. Smith opened a hotel in 1915 and named it the Laurel Falls Hotel. Smith operated the hotel until 1920, when he started a girls' summer camp. Smith's daughter Lillian helped her family run the hotel before taking a teaching position in China; she later returned to run the Laurel Falls Camp for Girls. (Dover and Green, Clayton.)

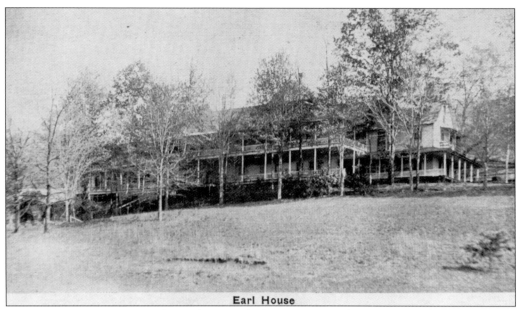

Earl House

EARL HOUSE, CLAYTON. The Earl House had 30 rooms in the main house, and the dining room could seat 112 guests. The hotel billed itself as a "comfortable, home-like boarding place for congenial guests." Patrons were offered fresh milk from cows on the meadow, along with spring water, and could enjoy outdoor activities such as tennis and golf. Restriction included: "gentiles only," "no persons suffering from Tuberculosis, pellagra or other contagious diseases," "no kleptomaniacs, dopes or intoxicants," "no card playing or dancing," "no babies or small children that make disturbances in the night," "no pets of any kind," and guests were expected to observe quiet after 10:00 p.m. Not wishing to dissuade visitors, the brochures clarified—"Do not misunderstand the Earl House to be long-faced . . . we solicit the cheerful jolly people who love fun." (Auburn Greeting Card Co., Auburn, Indiana.)

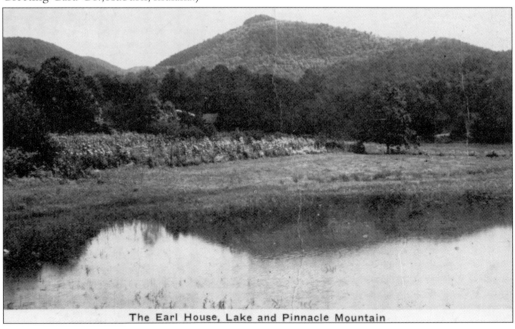

The Earl House, Lake and Pinnacle Mountain

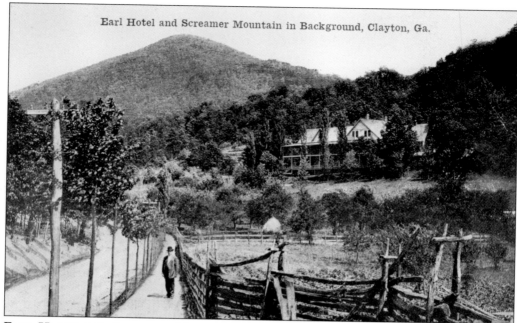

Earl Hotel and Screamer Mountain in Background, Clayton, Ga.

EARL HOUSE AND SCREAMER MOUNTAIN, CLAYTON. The Earl House was built in 1903 on a wooded knoll with a beautiful view of the Blue Ridge. Screamer Mountain towered behind the boardinghouse, and the dining room overlooked the Earl House Lake. The hotel was owned and operated by J.F. Earl and his wife, Leila. The hotel burned to the ground in 1940. (Blue Ridge Mountain Postcard Co., Tallulah Falls.)

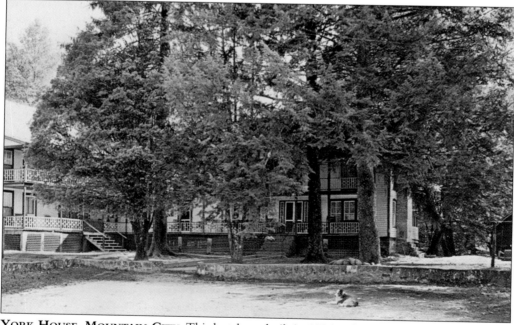

YORK HOUSE, MOUNTAIN CITY. This hotel was built in 1896 to house workers for the Tallulah Falls Railway. At the time of this c. 1915 picture, the hotel was under the management of Fannie York Weatherly (of the original family). The York House is listed in the National Register of Historic Places and remains a favorite tourist destination. (Dexter Press, West Nyack, New York.)

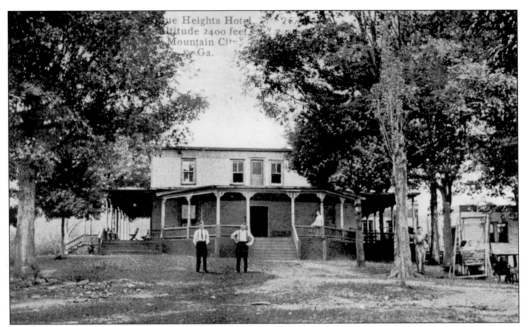

BLUE HEIGHTS HOTEL, MOUNTAIN CITY. The Blue Heights Hotel was located on State Highway 441/23. The hotel had large porches where guests could enjoy the cool mountain breezes. During the 1910s and 1920s, the hotel changed names and became the Mountain City Hotel. All that remains today is an old water tower. (J.C. Green, Merchant.)

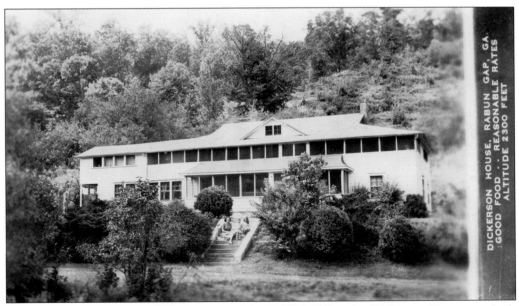

DICKERSON HOUSE, RABUN GAP. Located in Wolffork Valley, the Dickerson House was built starting in 1910 as a home for the Dickerson family. In the 1920s, the family started taking in boarders, and it was a popular boardinghouse until 1973. The boardinghouse did not have electricity until the 1940s, and the family grew most of the food they served.

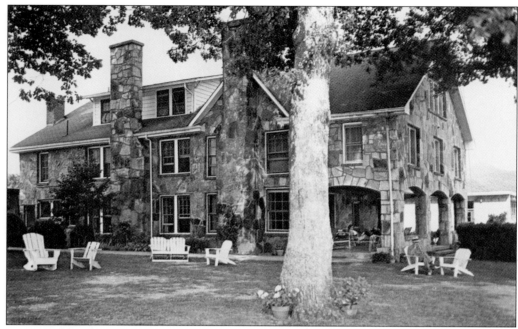

DILLARD HOUSE, DILLARD. John Dillard arrived in Rabun County in the 1700s, purchased land from the Cherokees, and his descendants have been there ever since. In 1917, Carrie and Arthur Dillard opened their home to their first commercial guest, a circuit preacher named Rev. Henry Byrd. The spacious main house (pictured) is built of native stone. (Chester Litho Corp., Chester, New York.)

DILLARD HOUSE EXPANDS. Word quickly spread about the Dillards' Southern hospitality and great home cooking. Over several generations, the business has added a 200-seat dining room overlooking the Little Tennessee River valley, where the fertile land nurtured local produce. The Dillards also built a hotel, conference center, petting zoo, and stables. (Gene's Camera House, Franklin, Georgia.)

Four

SUMMER CAMPS

The tradition of summer camps originated in 1876 in the Swiss Alps under the leadership of Pastor Bion and spread around the world. Georgia parents sought temperate places where their children could socialize, enjoy outdoor exercise, and learn new things while they were away from crowded cities. The opening of the railroad to Rabun County provided convenient travel from larger cities due south. The cool summer climate, woods, lakes, streams, and beauty of Rabun County made it a favorite place for parents to send their children.

In 1898, the YMCA in Athens, Georgia, established a camp in Tallulah Falls (founded by W.T. Forbes), which is now the fifth-oldest YMCA camp in the United States. Other camps established by various organizations before 1950 include Camp Cherokee, Camp Dixie for Boys, Camp Dixie for Girls, Laurel Falls Camp for Girls, and Camp Pinnacle. From Christian retreats to wilderness camping for scouts, Rabun County provides the perfect setting for summer's youth.

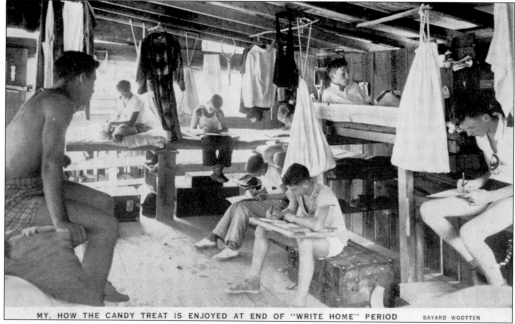

CAMP DIXIE FOR BOYS, WILEY. The front of this card says, "My, how the candy treat is enjoyed at the end of 'write home' period." The camp, located in Wiley, was filled to capacity for decades. The Wiley camp no longer exists, as the land was sold, after which this camp merged with the girls camp located in the Germany area of Rabun County. (Bayard Wootten.)

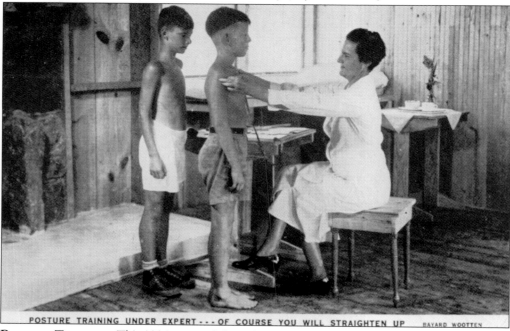

POSTURE TRAINING UNDER EXPERT - - - OF COURSE YOU WILL STRAIGHTEN UP BAYARD WOOTTEN

POSTURE TRAINING. This 1936 postcard shows boys going through posture training—"of course you will straighten up." Camp Dixie was started in 1914 by A.A. Jameson, known to most as "Pop J." Prior to starting his own camp, Jameson worked for the YMCA for 26 years, setting up camps all over the country. (Bayard Wootten.)

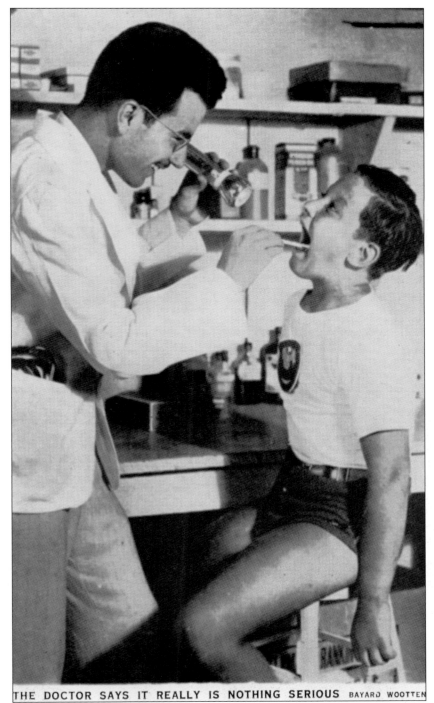

THE DOCTOR SAYS IT REALLY IS NOTHING SERIOUS BAYARD WOOTTEN

DOCTOR AT CAMP DIXIE. Boys in the camp not only had a great time, they were also looked after by medical staff. This postcard shows a doctor giving a throat exam and states: "The doctor says it really is nothing serious." Privies at the camp were nicknamed "The Lighthouses" because they were the only buildings that always kept a light burning; the nickname is still used today. (Bayard Wootten.)

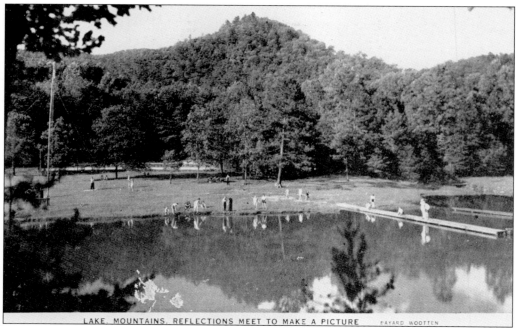

LAKE. MOUNTAINS. REFLECTIONS MEET TO MAKE A PICTURE BAYARD WOOTTEN

CAMP DIXIE FOR GIRLS, GERMANY. Camp Dixie for girls was started in 1919 in the Germany area of Rabun County. Here, groups of girls are having fun at the lake at the base of the mountain. In 1938, one camper wrote: "This is certainly a beautiful location for a camp and I am having a lot of fun." (Bayard Wootten.)

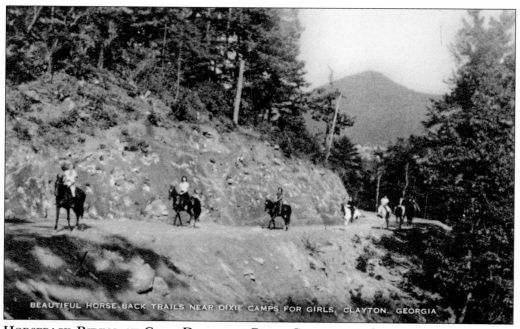

BEAUTIFUL HORSE-BACK TRAILS NEAR DIXIE CAMPS FOR GIRLS, CLAYTON. GEORGIA

HORSEBACK RIDING AT CAMP DIXIE FOR GIRLS, GERMANY. A favorite outdoor activity at the camp was riding horses on the beautiful trails that meandered through the woods along dirt mountain roads. With 350 acres of land, there was plenty of room for exploring. (Artvue Post Card Co., New York.)

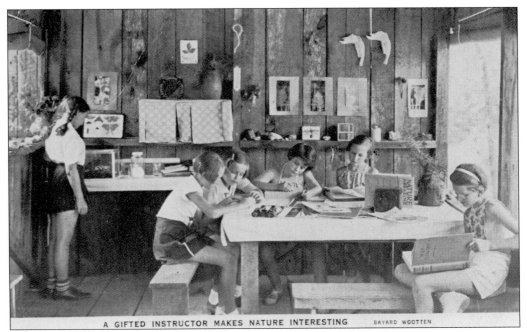

A GIFTED INSTRUCTOR MAKES NATURE INTERESTING BAYARD WOOTTEN

NATURE CLASS AT CAMP DIXIE FOR GIRLS, GERMANY. "A gifted instructor makes nature interesting," states this postcard. The girls in the picture are engrossed in the hands-on nature exhibits and in reading books. Girls at Camp Dixie find that time spent at camp is more than physical activities—it is an educational experience. (Bayard Wootten.)

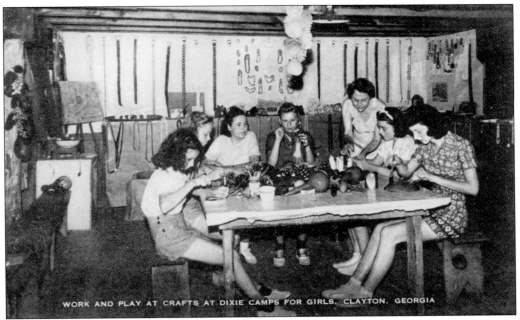

WORK AND PLAY AT CRAFTS AT DIXIE CAMPS FOR GIRLS. CLAYTON. GEORGIA

CRAFTING AT CAMP DIXIE FOR GIRLS, GERMANY. What summer camp would be complete without arts and crafts? Girls in this 1950s picture appear to be making crafts utilizing nature's bounty, such as pinecones and gourds. (Artvue Post Card Co., New York.)

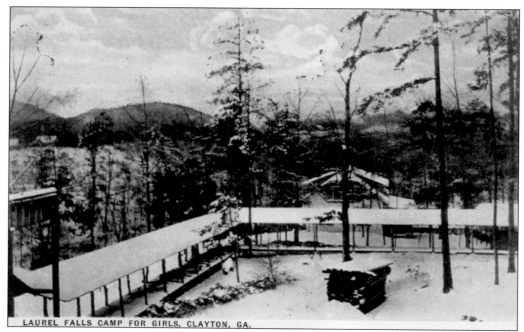

LAUREL FALLS CAMP FOR GIRLS, CLAYTON, GA.

LAUREL FALLS CAMP FOR GIRLS, CLAYTON. After losing his Florida turpentine mills in 1915, C. W. Smith moved his family to land they owned in Clayton and started the Laurel Falls Camp for Girls in 1920. The various camp buildings were attached by a covered walkway, which is visible in this winter snow scene. (Commercial Chrome.)

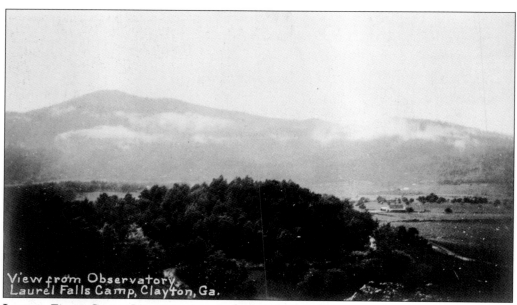

View from Observatory, Laurel Falls Camp, Clayton, Ga.

LAUREL FALLS CAMP OBSERVATORY, CLAYTON. Before taking over the camp from her ailing father in 1925, Lillian Smith attended school at Piedmont College in Demorest, Georgia, and the Peabody Conservatory in Baltimore, Maryland. She taught in two mountain schools and then spent a year teaching in China; she brought her love of education to the camp. (Herbert E. Glasier and Co., Boston.)

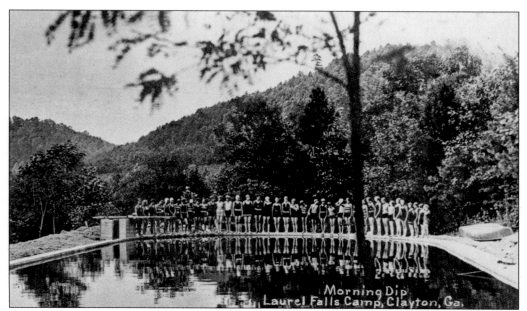

MORNING SWIM AT LAUREL FALLS CAMP, CLAYTON. Lillian Smith was outspoken about the issue of race relations in the South. In 1942, while running the camp, she started a magazine called *South Today*. Two years later, she published her best-selling novel about interracial love, *Strange Fruit*, which was banned in Massachusetts for a short time. This photograph shows campers lined up along the edge of the pool for a morning swim. (Herbert E. Glasier & Co., Boston.)

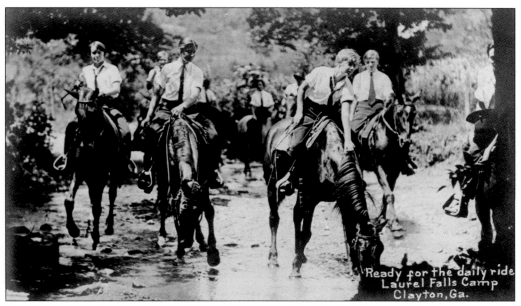

DAILY RIDE AT LAUREL FALLS CAMP, CLAYTON. Horseback riding was a popular activity at the camp. In 1925, Lillian Smith took over the administration of the camp from her father, C. W. Smith, and ran it until 1949, when she closed the camp to concentrate on her writing. Smith's first major literary success came from her controversial book *Strange Fruit*, published in 1944. (Herbert E. Glasier & Co., Boston.)

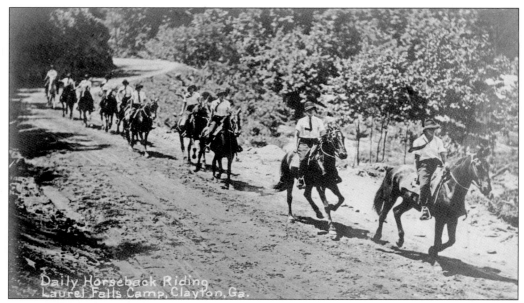

Daily Horseback Riding
Laurel Falls Camp, Clayton, Ga.

TRAIL RIDING AT LAUREL FALLS CAMP, CLAYTON. In 1966, Lillian Smith died and was buried on the camp ridge with the gymnasium chimney as a monument. The property is now owned by the Lillian E. Smith Foundation, which runs the Lillian E. Smith Center for Creative Arts, a sanctuary where artists and scholars can work in privacy and solitude. (Herbert E. Glasier & Co., Boston.)

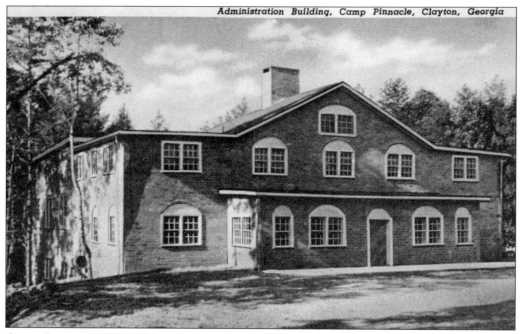

Administration Building, Camp Pinnacle, Clayton, Georgia

CAMP PINNACLE, CLAYTON. Camp Pinnacle is a more recent addition to camp life in Rabun County. The camp, opened in 1947 by the Georgia Baptist Woman's Missionary Union, is still in use today as a girls' camp in the summer and year-round for church retreats and conferences. The administration building is shown in this 1950s postcard. (Curt Teich Company, Chicago.)

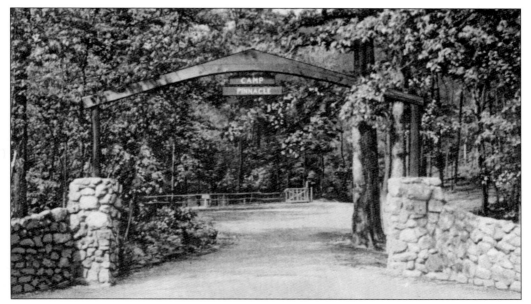

CAMP PINNACLE ENTRANCE, CLAYTON. The entranceway to the camp was built with native stones on either side of the driveway and an arched sign overhead. The dining hall can feed more than 168 campers, plus staff. Inside the camp, the mission has never wavered: "it is a place dedicated to God; to lead people to Christ, to develop Christian character, and to promote world missions." (Curt Teich Company, Chicago.)

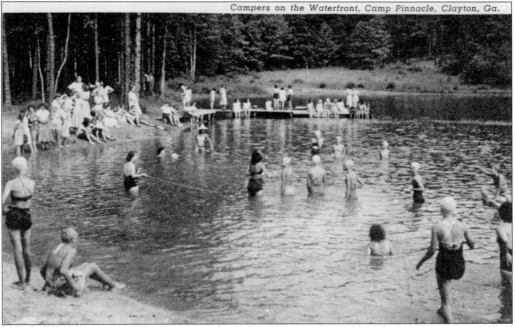

Campers on the Waterfront, Camp Pinnacle, Clayton, Ga.

SWIMMING IN THE LAKE AT CAMP PINNACLE, CLAYTON. Camp facilities include cabin housing, a chapel, a lodge, a guesthouse, a junior-size Olympic swimming pool, a gymnasium, walking trails, a prayer garden, a lake, a lakeside amphitheater, and a wellness center. Here, girls enjoy swimming in the lake. The camp, named after Pinnacle Mountain, is located one-and-a-half miles from the city of Clayton. (Curt Teich Company, Chicago.)

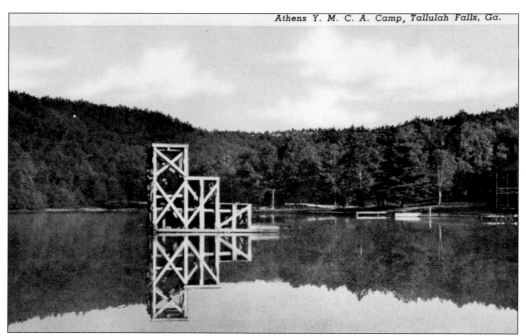

ATHENS YMCA CAMP, TALLULAH FALLS. This YMCA summer camp was founded in 1898 and directed by Walter T. Forbes for 42 years. The camp is the fifth-oldest "Y" camp in America and is still in operation after more than a century of serving generations of campers. (Artvue Post Card Co., New York.)

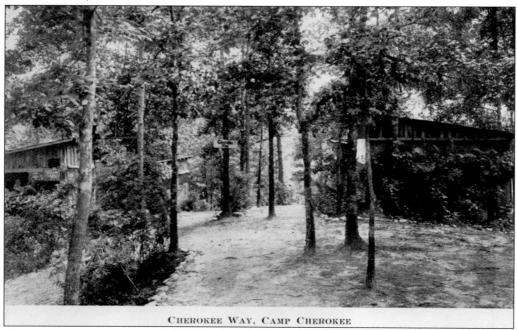

CHEROKEE WAY, CAMP CHEROKEE

CAMP CHEROKEE, LAKE BURTON. Camp Cherokee was located on the back side of Lake Burton. It was founded by the McConnell family after the Georgia Power lake was built. This 1928 postcard shows the Cherokee Way and several buildings nestled in the woods. This camp was successful for decades, but it is now gone. (Camp Cherokee, Clarkesville.)

60

Five

EDUCATION AND RELIGION

Since 1819, more than 106 different schools have been located in Rabun County. Most of these were small, one-room buildings serving a few families in isolated parts of the county. As transportation improved, these community-based schools were replaced with larger consolidated public schools. Many of the early schools were affiliated with religious institutions and service organizations; the Bleckley Memorial Institute was affiliated with the Baptists and the Rabun Gap Industrial School (now the Rabun Gap–Nacoochee School) was affiliated with the Presbyterians, while the Tallulah Falls School was funded by the Georgia Federation of Women's Clubs and the library of Clayton High School was funded by the Clayton Woman's Club.

Like the schools, churches were spread all over the county in efforts to reach isolated communities. Churches not only provided citizens with religious teachings but were centers for social gatherings. While many small churches have been lost over the years, there are still dozens of churches in the county that serve various communities large and small.

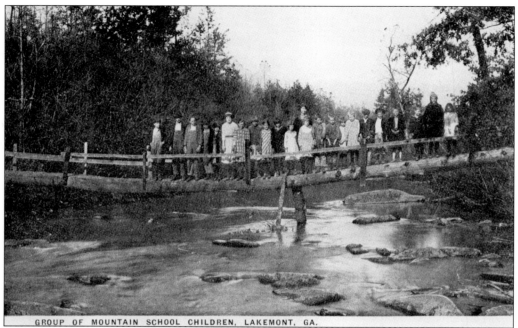

GROUP OF MOUNTAIN SCHOOL CHILDREN, LAKEMONT, GA.

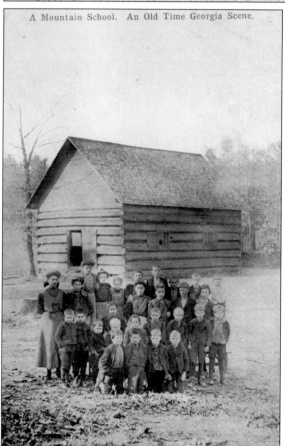

A Mountain School. An Old Time Georgia Scene.

SCHOOLCHILDREN, LAKEMONT.
This 1920s postcard shows a group of children on an old wooden bridge in Lakemont. Most kids walked to school; it was 1929 when the first "homemade" bus came to the county, running a route from Timpson to Clayton, and a manufactured bus was not purchased until 1936. (Smith & Davis, Lakemont.)

MOUNTAIN SCHOOL, NORTH GEORGIA. Rabun County, being a rural area, established small community schools through the county. In 1895, there were 36 white schools and 2 colored schools; most of the structures were simple one-room log or frame buildings like the one in this c. 1907 postcard. (Blue Ridge Mountain Postcard Co., Tallulah Falls.)

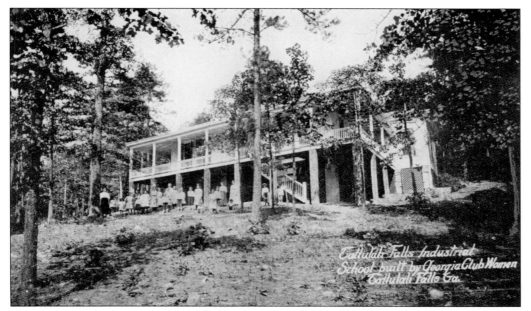

TALLULAH FALLS SCHOOL, TALLULAH FALLS. The Tallulah Falls School opened its doors on July 12, 1909, to 21 mountain children from Habersham and Rabun Counties. The school was started by Mary Ann Lipscomb of Athens, who saw a need for a rural student boarding school and used her position as president of the Georgia Federation of Women's Clubs to start it. (Blue Ridge Mountain Postcard Co., Tallulah Falls.)

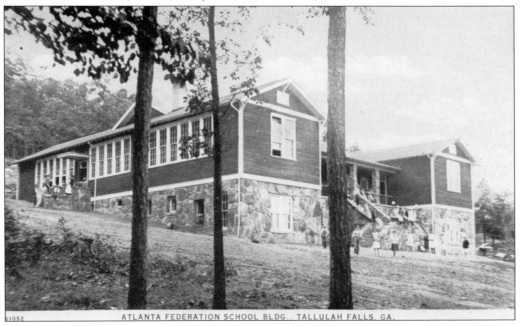

ATLANTA FEDERATION SCHOOL BUILDING, TALLULAH FALLS SCHOOL, TALLULAH FALLS. This image from the 1920s or 1930s shows the Atlanta Federation School Building. Often called the "Light in the Mountains," the school prospered and continues as a place of learning for local— as well as national and international—students. It remains under the ownership and management of the Georgia Federation of Women's Clubs. (Walter Hunnicutt, Tallulah Falls.)

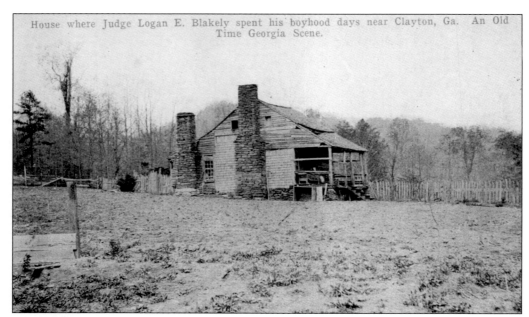

JUDGE BLECKLEY HOME, NEAR CLAYTON. This c. 1907 postcard shows the house where Judge Logan E. Bleckley grew up. Bleckley served as chief justice of the Georgia Supreme Court. Bleckley became famous not only for his law talents but for his love of education, which he demonstrated by taking a mathematics course at the University of Georgia at the age of 73. (Blue Ridge Mountain Postcard Co., Tallulah Falls.)

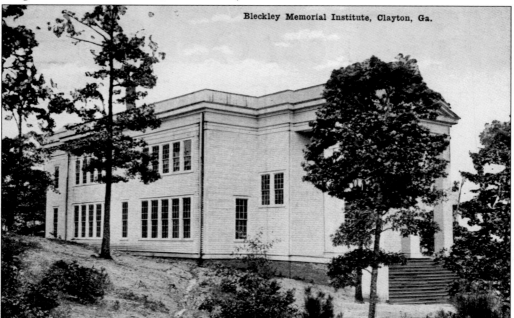

Bleckley Memorial Institute, Clayton, Ga.

BLECKLEY MEMORIAL INSTITUTE, CLAYTON. After the death of Judge Bleckley in 1907, his widow donated land and money for the building of a Mountain Mission School in Clayton. In 1913, the Bleckley Memorial Institute began classes under the administration of the Georgia Baptist Home Mission Board. In the 1920s, the school and one of the dormitories burned down, and the school never reopened. (Dover and Green, Clayton.)

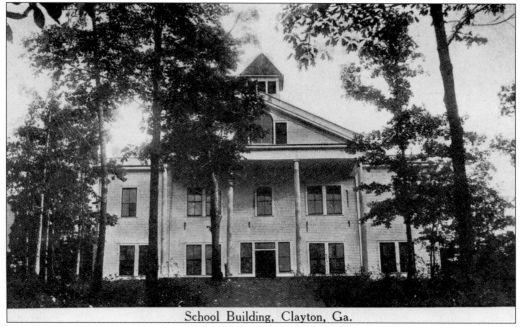

School Building, Clayton, Ga.

CLAYTON HIGH SCHOOL BUILDING. Clayton High School was built in the early 1900s on a picturesque ridge above Clayton. The school was a lovely two-story building that housed four classrooms, study halls, an assembly room, and a library furnished by the Clayton Woman's Club. In 1915, records show that 275 students attended the school. (Dover and Green, Clayton.)

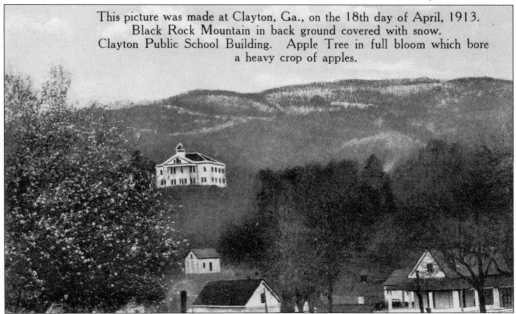

This picture was made at Clayton, Ga., on the 18th day of April, 1913. Black Rock Mountain in back ground covered with snow. Clayton Public School Building. Apple Tree in full bloom which bore a heavy crop of apples.

CLAYTON PUBLIC SCHOOL. This picture from April 18, 1913, shows Black Rock Mountain covered in snow while an apple tree blooms in the foreground; the card states that the apple tree went on to bear a heavy crop of apples. By the 1920s, the student population outgrew this facility, and a new school was built closer to town; the last class graduated from this school in 1927. (Dover and Green, Clayton.)

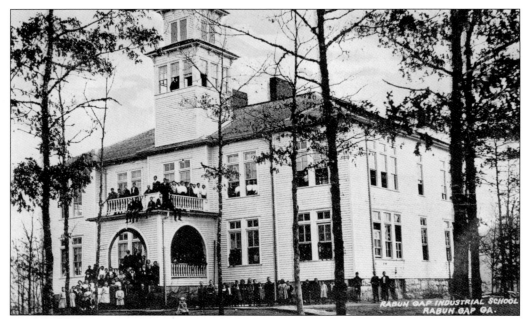

RABUN GAP INDUSTRIAL SCHOOL, RABUN GAP. This 1908 postcard shows the Rabun Gap Industrial School, which was founded in 1905 by Andrew Jackson Ritchie and his wife, Addie Corn, to help educate the isolated children of the area. The school was also a working farm, and children worked every day to provide food, maintain the school, and pay tuition. A 1926 fire destroyed the original building seen here. (Blue Ridge Mountain Postcard Co., Tallulah Falls.)

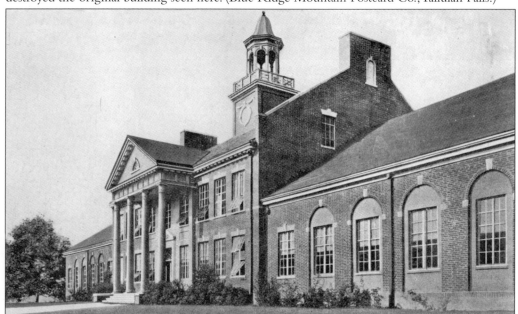

RABUN GAP–NACOOCHEE SCHOOL, RABUN GAP. In 1926, fire destroyed the main classrooms at both the Rabun Gap Industrial School and the Nacoochee Institute, which was located in White County, Georgia. As a result, the two schools merged to become the Rabun Gap–Nacoochee School. This postcard shows Hodgson Hall, which contained the classrooms, chapel, library, auditorium, and offices of the school. (Curt Teich Company, Chicago.)

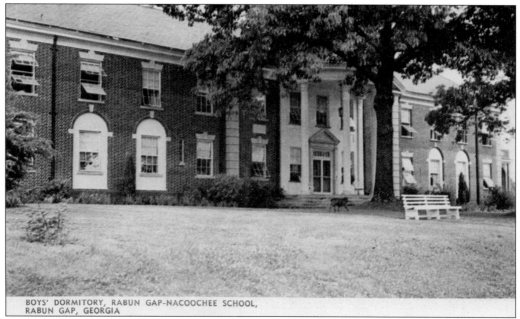

BOYS' DORMITORY, RABUN GAP-NACOOCHEE SCHOOL,
RABUN GAP, GEORGIA

BOYS' DORMITORY AT RABUN GAP–NACOOCHEE SCHOOL, RABUN GAP. This postcard shows the dormitory in the 1950s or 1960s. The Rabun–Gap Nacoochee School billed itself as "a place where young and old—day pupil, boarding pupil, and adult—work their way at farming and domestic industries." Whole families sometimes lived and worked on the farms while the kids went to school. Today, Rabun Gap–Nacoochee School is a private college preparatory boarding and day school serving students in grades six through 12. (Henry Hahn, Banner Elk, North Carolina.)

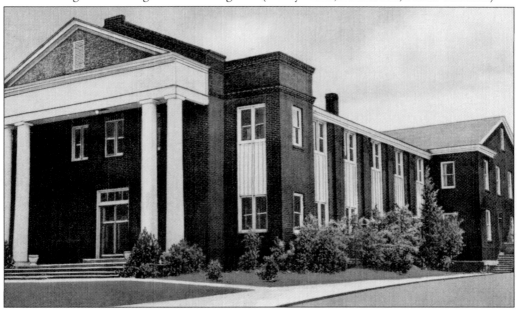

CLAYTON BAPTIST CHURCH, CLAYTON. A wooden church was built in 1870 just off Main Street on property donated by Thomas "Red" Kelly in 1850. In 1925, a brick building replaced the wooden church, and the Clayton Baptist Church has expanded numerous times since then. (Asheville Post Card Co., Asheville.)

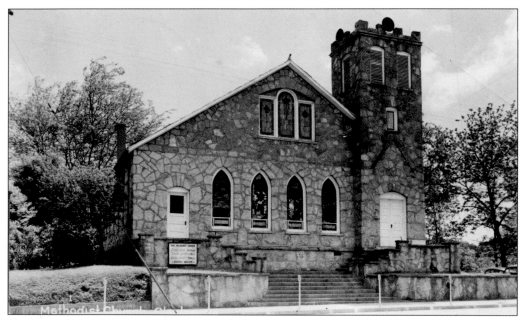

CLAYTON FIRST UNITED METHODIST CHURCH, CLAYTON. In 1878, this church (pictured in the 1950s) was built on Main Street. In 1923, the frame church was enlarged and faced with rocks donated by a Mr. Kerr from stone culverts meant to be part of the Blue Ridge Railroad line that was never completed. Today, the church has a beautiful Gothic cathedral interior and stunning stained-glass windows.

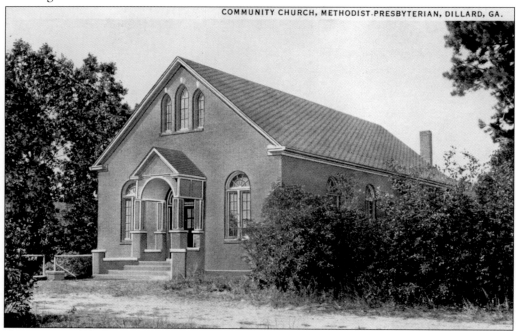

COMMUNITY CHURCH, METHODIST-PRESBYTERIAN, DILLARD, GA.

METHODIST-PRESBYTERIAN COMMUNITY CHURCH, DILLARD. In 1931, a new church was built in Dillard on land donated by Mr. and Mrs. Happ. The church held services for both Methodists and Presbyterians. Unfortunately, the church burned in 1947, and the two denominations then decided to build separate churches. (Curt Teich Company, Chicago.)

Six

COUNTY SEAT

The land for the county seat, originally called Dividings, was selected because natural topography placed it on a plateau where three major Cherokee trails—along valleys from the north, east, and west—came together. On December 15, 1821, the Georgia legislature designated land in lot 20 as the county seat, named it Claytonsville for the Hon. Augustus S. Clayton, and incorporated it as a town. Judge Clayton presided over the first sessions of the Superior Court, served as a Georgia congressman, and was important to the development of early Georgia.

In an act on December 13, 1823, the general assembly changed the county seat to land lot 21, shortened the name to Clayton, and incorporated it as a town. In 1824, the Inferior Court purchased 67 acres of land from Solomon Beck for $150 on which to build the town proper. According to the book *Sketches of Rabun County History*, Obidiah Dickerson platted the city, and the first land lots were sold in 1825.

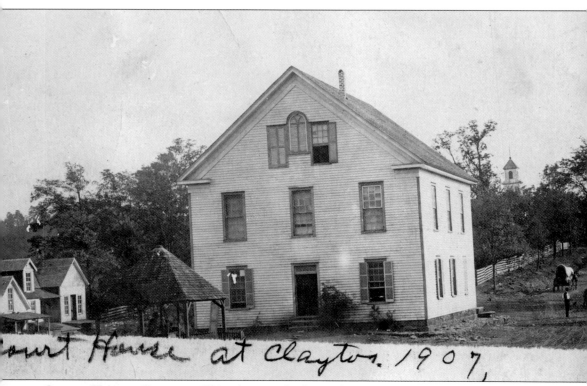

Court House at Clayton. 1907,

COURT HOUSE, CLAYTON. This photograph shows the Rabun County Court House at its original location on the public square. Rabun County had two log courthouses. The first log structure operated from 1824 to 1836, and the second from 1836 to 1878. In 1878, the wood frame structure shown here was built. In 1907, this building was condemned and bids were taken for the building of a new courthouse, to be built just west of Main Street at the site of the present-day courthouse. This building was then moved to a hill overlooking Savannah Street, across from the train depot, where it became a hotel called the Bleckley House.

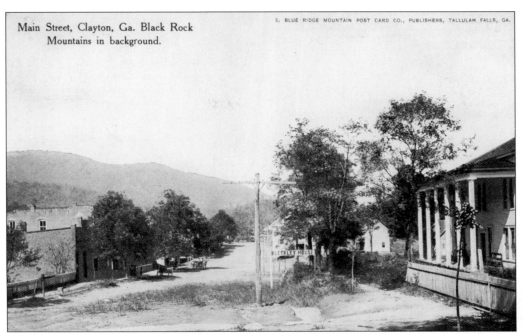

Main Street, Clayton, Ga. Black Rock
Mountains in background.

BLECKLEY HOUSE, CLAYTON. On the left side of the card pictured above is the redbrick building that housed the Bank of Clayton. On the right side is the original Bleckley House, which would later become the Hotel Dozier (and then Hotel Green). Looking closely down the street, one can just make out—on the other side of the telephone pole and trees—the white frame building that was the county courthouse. The white frame building in the below image was purchased by James E. Bleckley. The building was relocated down Savannah Street, near the depot, porches were added, and the building was converted into the Bleckley House Hotel. In the 1960s, the building was moved to its present-day location behind the Savannah Street Shops. (Above, Blue Ridge Mountain Postcard Company, Tallulah Falls; below, Dragner-Nyvall Co., College Point.)

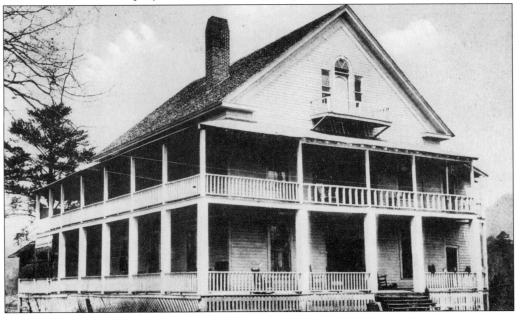

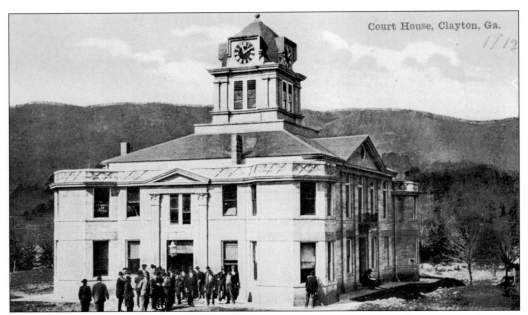

COURTHOUSE, CLAYTON. In 1907, the grand jury condemned the courthouse located on the public square, and the Ordinary of Rabun County took bids for the construction of a new building. Falls City Construction Company won the bid at $24,797. The new courthouse (pictured) was completed in 1908 on the site of the present-day courthouse. (Blue Ridge Mountain Postcard Co., Tallulah Falls.)

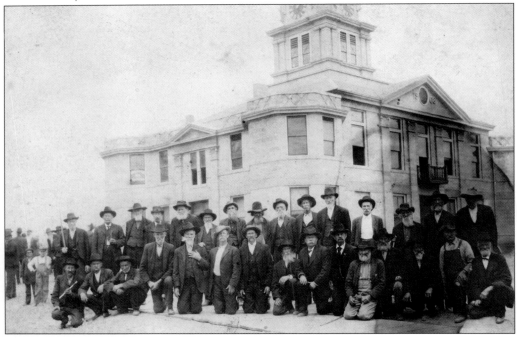

GATHERING IN FRONT OF THE COURTHOUSE. This photograph shows what appears to be a reunion of Confederate veterans in front of the new county courthouse, which opened in 1908. Note the man on the left end of the front row proudly holding his fife, the man above him with a sword, and the man near the center of the front row with his hand over his heart.

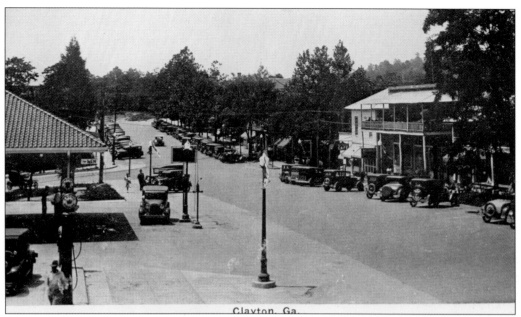

Clayton, Ga.

MAIN STREET, CLAYTON. This Main Street view shows the Roy Green Café on the right side at the corner of Main Street and Savannah Street. The café advertised: "When in Clayton just have a meal at Roy Green's Cafe." On the left side of the picture is the red-tile roof overhang of the Derrick Standard Oil Station, where Prater's Main Street Books is now located. (Auburn Greeting Card Co., Auburn, Indiana.)

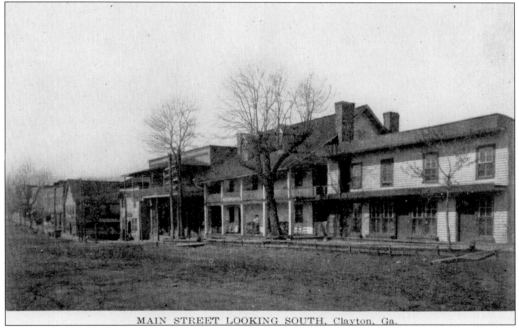

MAIN STREET LOOKING SOUTH, Clayton, Ga.

MAIN STREET C. 1907, CLAYTON. This view of Main Street looking south shows the Blue Ridge Hotel and Annex, which was a prominent landmark for over 90 years. Rocking chairs line the front porch of the hotel. To the left of the hotel was a two-story building with a second-story veranda; the bottom floor housed the Rabun County Bank from 1910 to 1913.

73

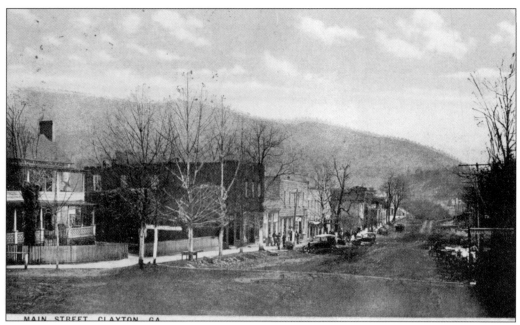

MAIN STREET CLAYTON GA

TUSCAWILLA INN, CLAYTON. This postcard of Main Street, with its dirt road, shows a white building at left called the Tuscawilla Inn. After the inn burned, it was replaced with a brick building and renamed the Clayton Hotel. The message on the back of this card reads, in part: "The X shows my room here. The brick building next door is the bank." (Commercial Chrome.)

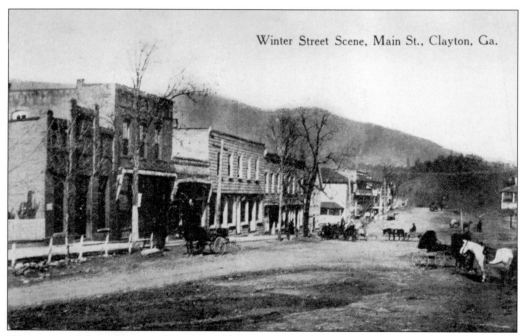

Winter Street Scene, Main St., Clayton, Ga.

WINTER ON MAIN STREET, CLAYTON. This scene shows Main Street looking north. At left is the Bank of Clayton, and in the distance—on the same side of the street—is the Blue Ridge Hotel. Around 1907, when this photograph was taken, the main modes of transportation on the street were horse and wagon. (Dover and Green, Clayton.)

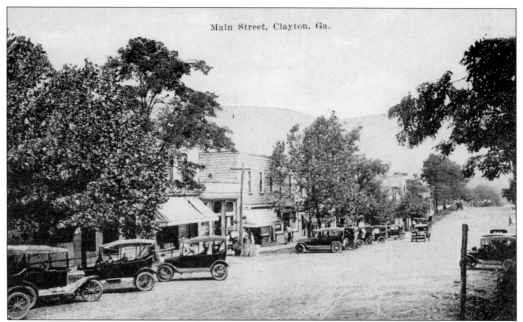

Main Street, Clayton, Ga.

MAIN STREET C. 1920, CLAYTON. This postcard shows the same view as the previous card. In comparing the two, several changes can be noted; some of the buildings now sport new awnings, and the horses and buggies have been replaced by automobiles. (Dover and Green, Clayton.)

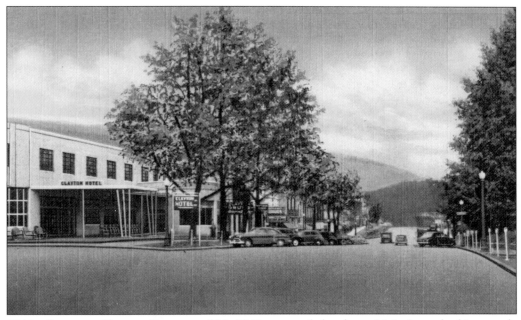

1940S CLAYTON HOTEL, CLAYTON. This 1940s postcard also shows Main Street looking north, but from a more southerly vantage point. The first building at left is the Clayton Hotel, with the new drugstore next door. Behind the trees, the top of the bank is barely visible. The parking meters are a sign of a more modern era. (Curt Teich Company, Chicago.)

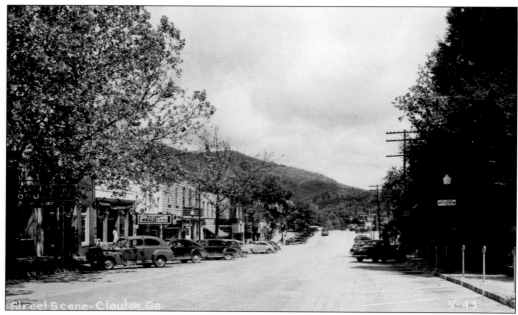

MAIN STREET LOOKING NORTH, CLAYTON. This 1950s postcard shows Main Street. Starting with the drugstore at near left and continuing down the row are the bank building, the movie theater, the supermarket, the five-and-dime store, the hardware store, and the café. Far down the row and across the street from the café, the Standard Oil sign is visible outside of the building where Prater's Main Street Books now operates. (W.M. Cline Company, Chattanooga.)

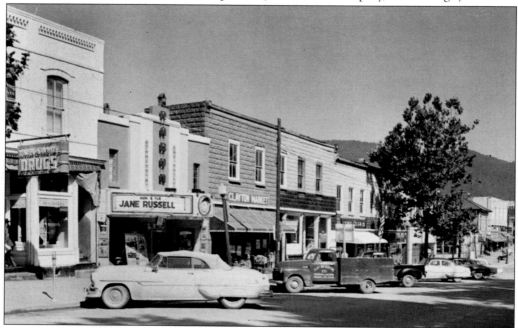

MAIN STREET, 1960s, CLAYTON. This postcard offers an even better view of the Dover and Green Drug Store, the Rabun Theater, and the Clayton Market. The supermarket sports a new sign, and parked in front of the drugstore is a nice convertible. The back of the card states that the population at this time was around 1,400. (W.M. Cline Company, Chattanooga.)

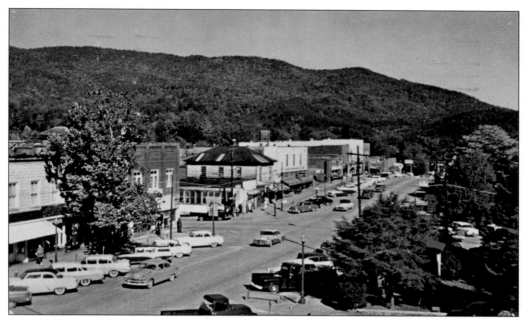

AERIAL VIEW OF MAIN STREET, CLAYTON. The back of this 1960s card reads: "Center of Georgia's mountain vacationland and gateway to the Little Tennessee River Valley. Rising above the roofs of city stores is Black Rock Mountain, elevation 3,465 feet." In 1952, Georgia opened a state park on the mountain, and it is still treasured for its beauty and spectacular views. (H.S. Crocker Co., San Francisco.)

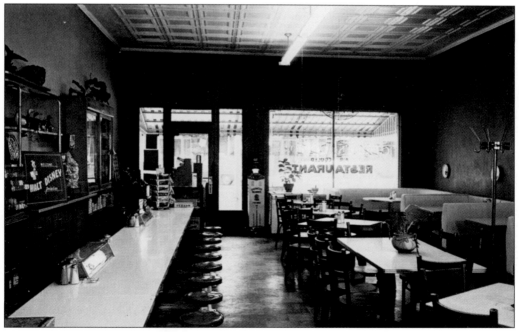

CAGLE'S RESTAURANT, CLAYTON. Cagle's Restaurant, located on Main Street, was very popular with both locals and tourists. This 1956 postcard shows the interior of the café with a large sign welcoming Walt Disney Productions and the cast and crew during the filming of *The Great Locomotive Chase*. The Clayton Café now operates in this location. (De Pew Adv. Co., Flat Rock.)

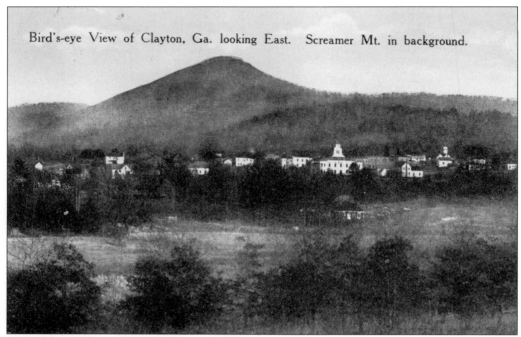

Bird's-eye View of Clayton, Ga. looking East. Screamer Mt. in background.

BIRD'S-EYE VIEW OF CLAYTON. This 1915 postmarked postcard looks east toward Screamer Mountain. Looking closely, one can see the new courthouse, built in 1908, just right of center. Over to the right, the steeple of the Methodist church is visible from when it was still a white frame structure. (Dover & Green, Clayton.)

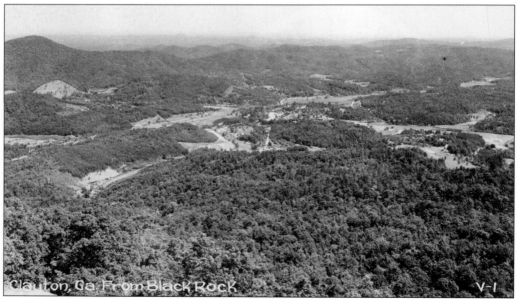

1950S VIEW OF CLAYTON FROM BLACK ROCK MOUNTAIN. This image shows what one can see from the state park atop Black Rock Mountain. Toward the left is Screamer Mountain. This view shows just how much of the land was still forested compared to the agricultural fields in the valleys. The railroad trestle is visible just north of town, on the left edge of the postcard. (W.M. Cline Company, Chattanooga.)

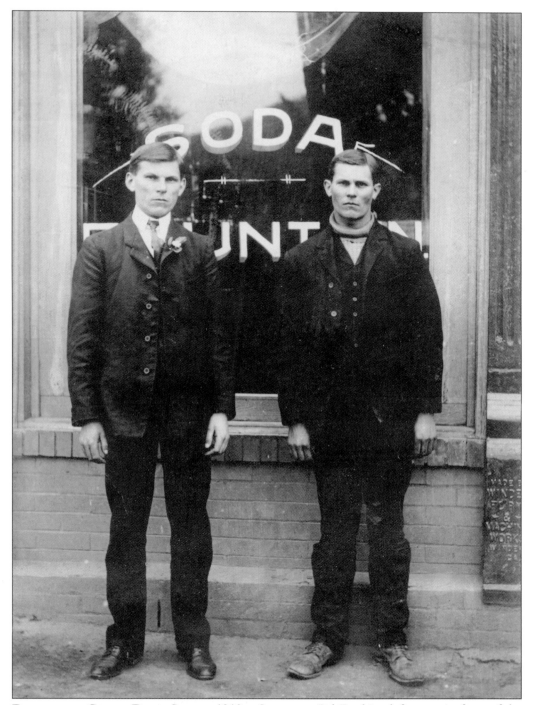

Dover and Green Drug Store, 1910s, Clayton. Bal Dockins, left, poses in front of the plate-glass window advertising the soda fountain at the Dover and Green Drug Store in downtown Clayton. Dockins is standing with an unidentified man in a turtleneck sweater who looks like he could be his brother. Dockins worked as a soda jerk in the drugstore before becoming the owner of the Forest Hill Inn.

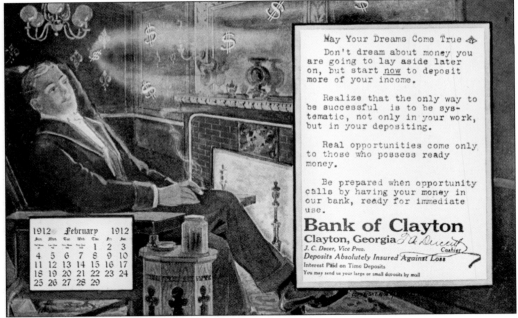

BANK OF CLAYTON CALENDAR. This February 1912 calendar postcard was used to advertise the Bank of Clayton. J.C. Dover was the vice president of the bank, and T.A. Duckett was the cashier. The card says, in part: "Realize that the only way to be successful is to be systematic, not only in your work, but in your depositing. Real opportunities come only to those who possess ready money." (Wesley Advertising Co., Chicago.)

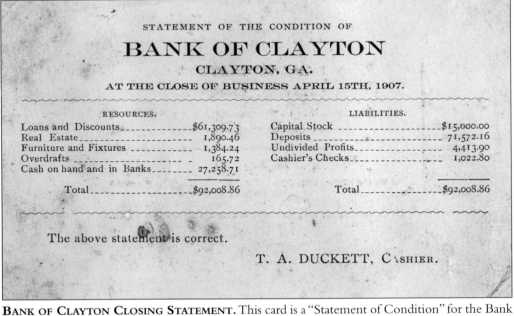

BANK OF CLAYTON CLOSING STATEMENT. This card is a "Statement of Condition" for the Bank of Clayton from the close of business on April 15, 1907. According to the statement, the bank had total deposits of $71,572.16. Directors listed on the back include J.W. Peyton, president; J.C. Dover, vice president; T.A. Duckett, cashier; W.H. Greenwood; Nelson Tilley; W.S. Long; W.S. Witham, financial agent; and W.J. Green. (Bank of Clayton.)

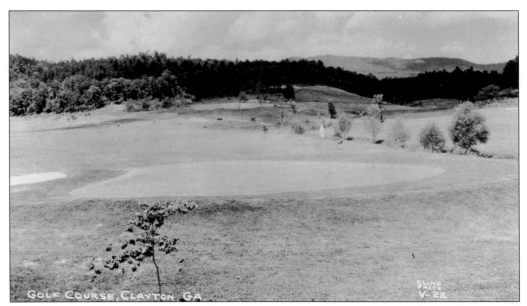

GOLF COURSE, CLAYTON. This 1940s postcard shows one of the holes on the Rabun Country Club golf course. The golf course, along with the clubhouse and swimming pool, was located on 125 acres of land just south of Clayton purchased in 1938 from Sheriff Luther Rickman. Estimated to cost $75,000, this was considered a very ambitious project for a city the size of Clayton. (W.M. Cline Company, Chattanooga.)

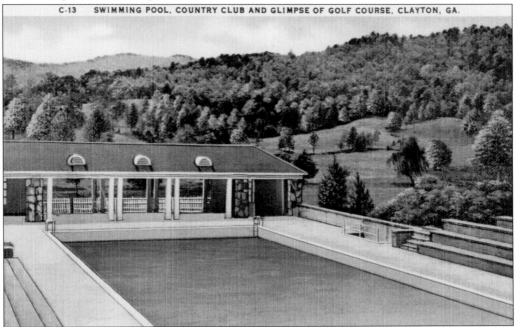

RABUN COUNTRY CLUB, CLAYTON. This 1940s postcard shows the swimming pool and golf course. To get the country club project underway, several citizens fronted money until the city could issue bonds. Works Project Administration funds and manpower were also used for the project. While the swimming pool has since been filled in, the golf course is still in use today. (Asheville Post Card Co., Asheville.)

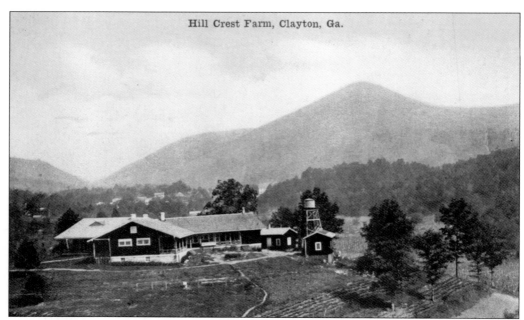

Hill Crest Farm, Clayton, Ga.

HILL CREST FARM, CLAYTON. The Hill Crest farm was located west of Clayton, off State Highway 76. It was built in 1907 as a summer home for the C. V. Le Craw family. The property was later purchased by a Mr. Parker and became known as the "Parker Ranch." The property has been a home, bed and breakfast, and—most recently—a private school. (Blue Ridge Mountain Postcard Co., Tallulah Falls.)

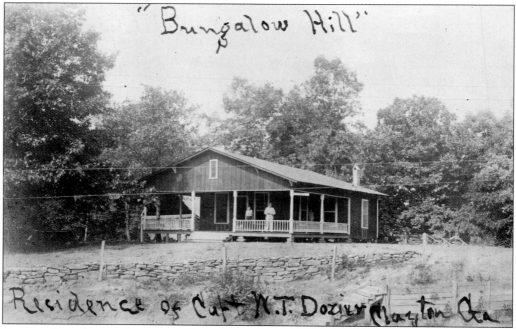

"Bungalow Hill"

Residence of Capt. W.T. Dozier Clayton Ga.

DOZIER RESIDENCE, CLAYTON. This real-photo postcard shows the home of Capt. W. T. Dozier, which the family called "Bungalow Hill." Captain Dozier was owner of the Clayton Hotel for a time before he sold it to Ed Holden. Typical of Southern homes, his bungalow had wide porches perfect for sitting outside and enjoying the mild summer climate. (Artur.)

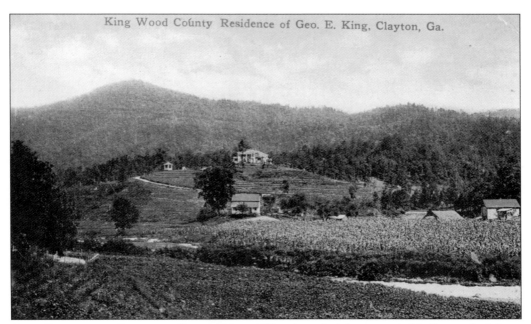

King Wood County Residence of Geo. E. King, Clayton, Ga.

KING RESIDENCE, CLAYTON. George Edward King, born in Macon, made his fortune in Atlanta with his company King Hardware. He owned a mansion in Inman Park but enjoyed spending cool summers at his mountain home near Clayton. This postcard, postmarked 1913, shows the King summer home. Though the house is gone, a country club that now occupies the property retains the name Kingwood. (J.E. Bleckley and Sons, Clayton.)

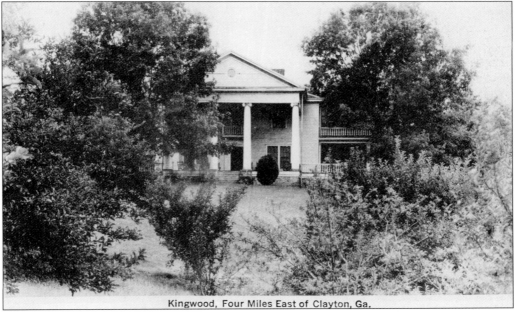

Kingwood, Four Miles East of Clayton, Ga.

KINGWOOD, CLAYTON. This beautiful home, called Kingwood, was located four miles east of town. Unfortunately, the house was allowed to sit abandoned and in disrepair until it was eventually torn down. The land that went with the home was developed into the Kingwood Country Club and Resort still in operation today. This postcard was postmarked 1939. (Asheville Post Card Co., Asheville.)

GENERIC GREETING, CLAYTON. Often, generic postcards were used to make local souvenirs. This is a c. 1907 embossed card featuring a young girl in a field of flowers. Glitter was used to write "Greetings from Clayton, GA," as well as to decorate the flowers.

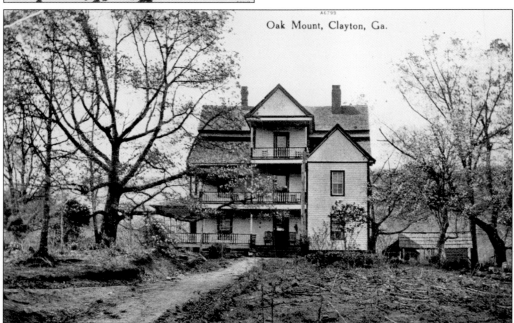

Oak Mount, Clayton, Ga.

OAK MOUNT, CLAYTON. This c. 1907 postcard features a three-story house. The location of the house has not been identified, so it is possible that the card is misidentified. However, since it was published by a local company, it begs to be studied further. (Blue Ridge Mountain Postcard Co., Tallulah Falls.)

Seven

A SCENIC COUNTY

For some, the gentle mountains of Rabun County may bring to mind the words of Psalm 121: "I will lift up mine eyes unto the hills, from whence cometh my help." For centuries, the lands in Rabun County have provided the essentials for man to survive: forests full of wildlife, clean abundant water, fertile valleys for farming, and an environment rich in medicinal plants. In 1775, William Bartram, the famous explorer and naturalist, traveled from the Chattooga River through Warwoman to Dividings (now Clayton), north to Passover (now Mountain City), and on to the top of Rabun Bald (the second-highest peak in Georgia). Bartram collected plant specimens and wrote extensively about the various plant species he discovered along the way.

After the influx of white settlers in the county, visitors came to witness the scenic vistas—from the bottom of the gorge at Tallulah Falls to the top of Rabun Bald, including wild rivers, majestic rock formations, and captivating waterfalls—that the native Cherokee had enjoyed for centuries The beginning of the 20th century saw the creation of many man-made attractions that added to the natural elements, such as lakes, public parks, campgrounds, and hiking trails.

WARWOMAN DELL, CLAYTON. Just east of Clayton is Warwoman Dell, located off Warwoman Road. During the Great Depression, the Civilian Conservation Corps undertook improvements in the dell, including picnic shelters and parking areas. The 129 workers were paid $1 per day, plus free shelter in tent-like facilities. The dell remains a popular location because it lies along the Bartram Trail and offers easy access to two nearby waterfalls, Becky Branch Falls and Martin Creek Falls. This postcard is postmarked 1938 and shows one of the CCC's picnic shelters. (Dover and Green, Clayton.)

GRAND CHASM, TALLULAH FALLS. This c. 1907 postcard shows the magnitude of the Grand Chasm cut through rock and stone by the mighty Tallulah River over thousands of years. After the river was dammed for hydroelectric plants, the water flow was greatly diminished. (Walter Hunnicutt, Tallulah Falls.)

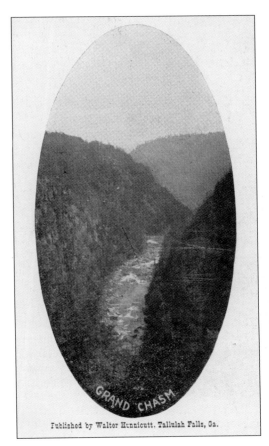

GRAND CHASM

Published by Walter Hunnicutt, Tallulah Falls, Ga.

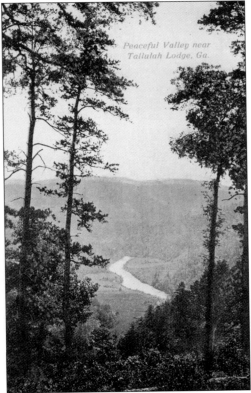

Peaceful Valley near Tallulah Lodge, Ga.

PEACEFUL VALLEY NEAR TALLULAH LODGE. This 1911 postcard shows the valley created by the Tallulah River down below the rocky gorge. Looking at the river below and the mountain range in the background, one can understand why so many people spent their summers at Tallulah Lodge and Tallulah Falls. (Blue Ridge Mountain Postcard Co., Tallulah Falls.)

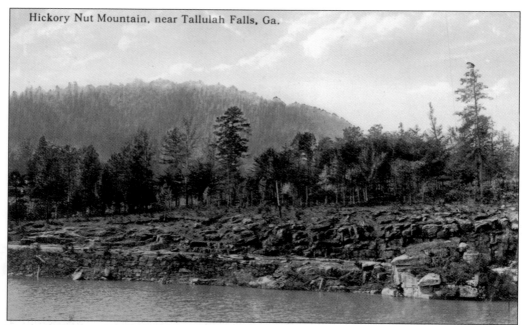

Hickory Nut Mountain, near Tallulah Falls, Ga.

TALLULAH LAKE, TALLULAH FALLS. This postcard, postmarked Tallulah Lodge 1915, shows a small portion of Tallulah Lake, its rocky shore, and Hickory Nut Mountain in the background. The back of the card reads, "This is the highest point near the Cliff House and is 2500 feet above sea level. It affords one of the favorite tramps for mountain climbers." (Curt Teich Company, Chicago.)

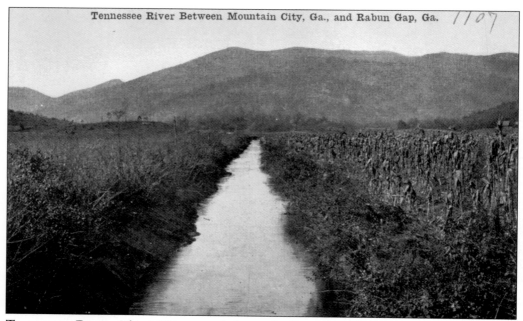

Tennessee River Between Mountain City, Ga., and Rabun Gap, Ga. 1107

TENNESSEE RIVER. This 1907 postcard shows the Tennessee River between Mountain City and Rabun Gap. The valley alongside the river contained fertile fields for farming; crops, such as the corn in this picture, continue to be grown there. (Blue Ridge Mountain Postcard Co., Tallulah Falls.)

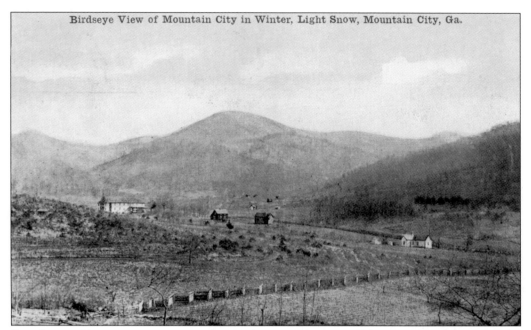

Birdseye View of Mountain City in Winter, Light Snow, Mountain City, Ga.

BIRD'S-EYE VIEW OF MOUNTAIN CITY. This c. 1907 postcard shows Mountain City in the winter. The tops of the mountains in the background are covered with a light snow. The sender of the card writes from the Earl House that she is "having a fine time . . . everything is lovely." (Blue Ridge Mountain Postcard Co., Tallulah Falls.)

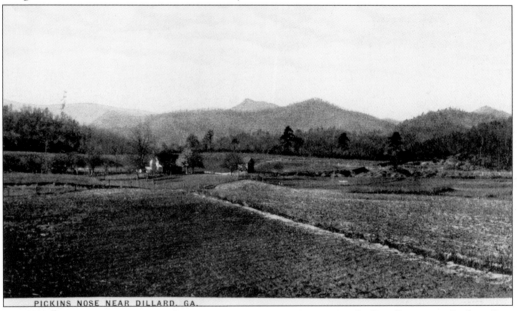

PICKINS NOSE NEAR DILLARD, GA.

PICKENS NOSE, DILLARD. Pickens Nose is a mountain in North Carolina named after Gen. Andrew Pickens, who fought in the Revolutionary War. A rocky outcropping at the summit was said to resemble Pickens's distinct nose. This c. 1920 postcard shows Pickens Nose (in the background) as seen from the agricultural fields surrounding Dillard. A trail to the summit, which is located in the Nantahala National Forest, is popular with locals and visitors to Rabun County. (Homer J. Deal, Dillard.)

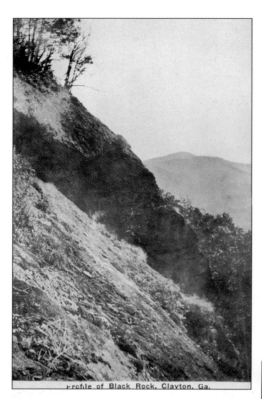

Profile of Black Rock, Clayton, Ga.

BLACK ROCK, CLAYTON. This c. 1910 postcard shows the profile of Black Rock. This rock face gives the mountain its name. Today, the Black Rock Mountain State Park has an overlook atop this rock formation that offers a spectacular view of the city of Clayton. The park also has a visitors' center, a playground, a campground, and hiking trails. (Dover and Green, Clayton.)

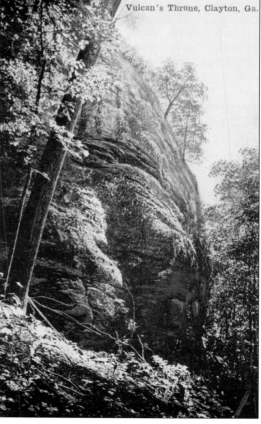

Vulcan's Throne, Clayton, Ga.

VULCAN'S THRONE, CLAYTON. Centuries of wind and rain wearing down the mountains have left Rabun County with massive rock formations and rock faces. Many of these have been given grand names, such as the one pictured in this c. 1910 postcard—Vulcan's Throne, located near Clayton. (Blue Ridge Mountain Postcard Co., Tallulah Falls.)

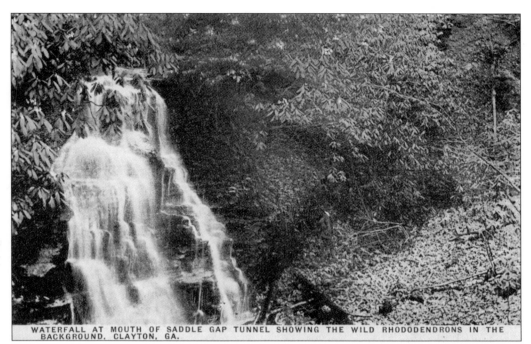

WATERFALL AT MOUTH OF SADDLE GAP TUNNEL SHOWING THE WILD RHODODENDRONS IN THE BACKGROUND, CLAYTON, GA.

SADDLE GAP TUNNEL, CLAYTON. In Warwoman Dell, to the east of Clayton, lies another abandoned tunnel project for the Blue Ridge Railway. This 1922 postcard shows the waterfall at the mouth of the tunnel. Today, there is only a hill of dirt with no visible sign of the tunnel having been dug. There are rumors that in 1858, the tunnel caved in, trapping workers. (Commercial Chrome.)

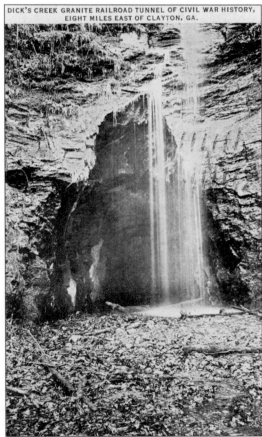

DICK'S CREEK GRANITE RAILROAD TUNNEL OF CIVIL WAR HISTORY, EIGHT MILES EAST OF CLAYTON, GA.

DICK'S CREEK, CLAYTON. In 1854, construction began on the Blue Ridge Railroad project section linking Walhalla, South Carolina, to Knoxville, Tennessee. In Rabun County, a tunnel was created at Dick's Creek, eight miles east of Clayton. Construction of the Blue Ridge Railroad stopped during the Civil War, and the depressed postwar economy led to the project being abandoned forever. A spring head waterfall veils the entrance, as seen in this 1934 postcard. (Asheville Post Card Co., Asheville.)

91

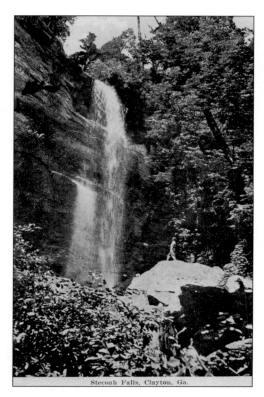

Stecoah Falls, Clayton, Ga.

STEKOA FALLS, CLAYTON. After meandering through Clayton, Stekoa Creek flows much faster as it heads southeast toward the Chattooga River. There are several waterfalls along the creek. The one pictured in this 1922 postcard, Stekoa Falls, is over 100 feet high. The waterfall is now on private land that is closed to the public. (Dover and Green, Clayton.)

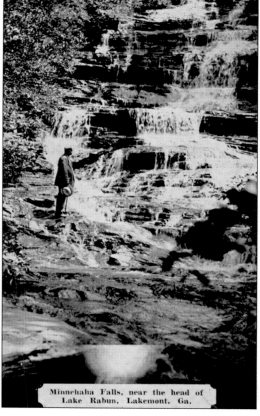

Minnehaha Falls, near the head of Lake Rabun, Lakemont, Ga.

MINNEHAHA FALLS, LAKEMONT. Considered one of the most beautiful waterfalls in northeast Georgia, Minnehaha is also one of the most photographed. Water cascades over stair-step rocks, catching and reflecting sunlight as it flows. One can get an idea of the size of Minnehaha by comparing the falls to the man in the picture. (Dexter Press, West Nyack, New York.)

ESTATOAH FALLS, DILLARD. This 1919 postcard shows the Estatoah Falls northeast of Dillard. The water drops hundreds of feet over many dramatic cascades. The sender of this card writes, "Wish you could see these falls and others near here." This is the waterfall visible on the side of the mountain on the right side of the road from Dillard to Sky Valley. (Dover and Green, Clayton.)

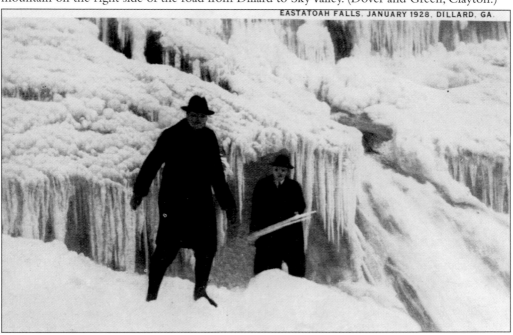

ESTATOAH FALLS IN WINTER, DILLARD. This waterfall, located on Mud Creek, was named after a Cherokee village once located in the valley near the falls. Mud Creek flows down the mountain from Sky Valley. Farther up the mountain is another waterfall called Mud Creek Falls. Estatoah Falls, located on private property, can be viewed from State Highway 246. This picture was taken during a hard freeze in January 1928. (Curt Teich Company, Chicago.)

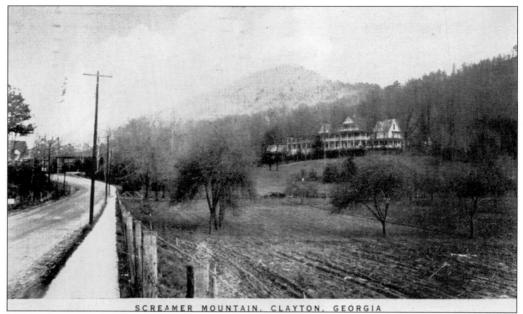

SCREAMER MOUNTAIN, CLAYTON, GEORGIA

SCREAMER MOUNTAIN, CLAYTON. This 1939 postcard shows Screamer Mountain. Legend has it that a Cherokee maid leapt to her death from this 3,200-foot mountain, thus giving the mountain its nickname. In 1839, the legal name of the mountain was changed to Bleckley Mountain in honor of Judge Logan E. Bleckley. However, to this day the mountain is still known as Screamer Mountain. (Dover and Green, Clayton.)

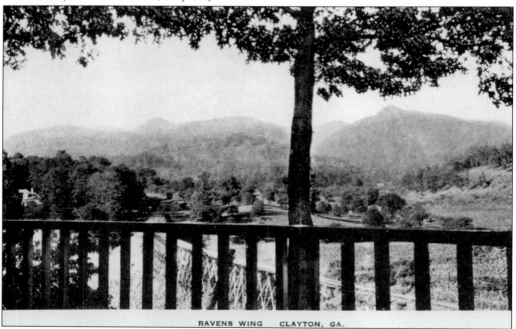

RAVENS WING CLAYTON, GA.

RAVENS WING, CLAYTON. The front porch of the Forest Hill Inn offers a breathtaking view of the mountain vistas. Look closely and the mountains form what appears to be the silhouette of a bird's head and wings, which earned the range the nickname Ravens Wing. (Stonecypher & McCurdy, Clayton.)

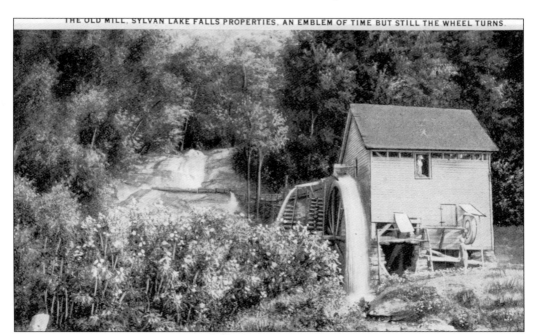

SYLVAN LAKE FALLS MILL, MOUNTAIN CITY. The grist mill at Sylvan Lake Falls dates back to 1840. It is a unique mill, with its huge, 27-foot overshot wheel powered by a 100-foot cascading waterfall. Today, the mill still grinds corn for the meal and grits that are sold in the Sylvan Falls Mill Bread and Breakfast. (Sylvan Lake Falls, Inc.)

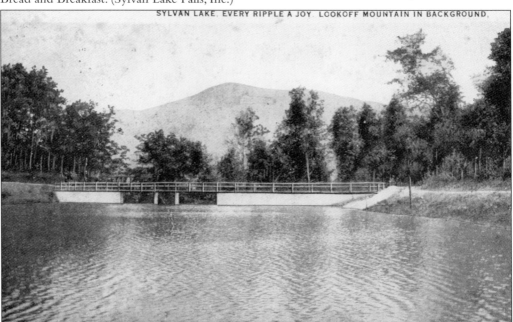

SYLVAN LAKE, MOUNTAIN CITY. This 1931 postcard shows the dam forming Sylvan Lake, around which land was subdivided. The inscription states: "If you have never seen this spot of dear old Georgia which God made with a SOUL, surrounded by natures masterpieces, nestled in the high altitudes of the scenic Blue-Ridge mountains . . . situated on the Great Divide . . . you should not deprive yourself of this privilege." (Sylvan Lake Falls, Inc.)

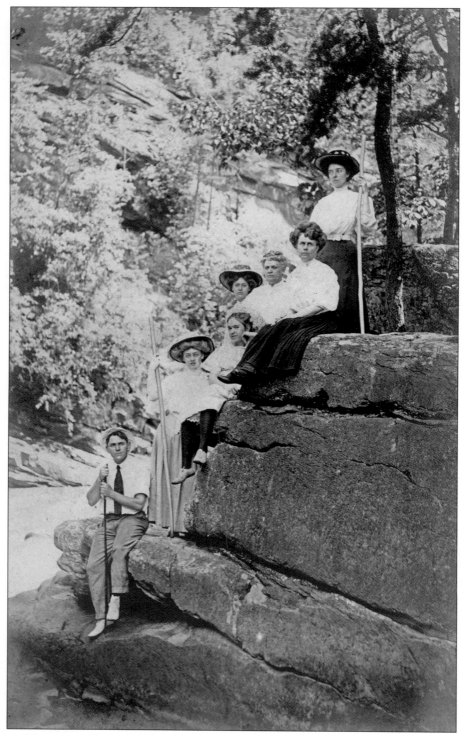

HIKERS, TALLULAH FALLS. In this c. 1910 postcard, an adventurous group of hikers poses on staircase rock formations in the 1,000-foot chasm. The Tallulah Gorge, which is approximately two miles long, was formed by the Tallulah River cutting through the rock over millions of years.

Eight

THE GREAT CHASM

The Tallulah River runs its 48-mile course south from North Carolina, through Rabun and Habersham Counties, and eventually converges with the Chattooga River to form the Tugaloo River. At the south end of Rabun County, the Tallulah River cut through the Tallulah Dome rock, creating a chasm (or gorge) over two miles long and more than 1,000 feet deep. Along the rocky path of the river, numerous waterfalls formed, which gave the area its name—Tallulah Falls.

As early as the mid-1800s, visitors began arduous trips to see the picturesque falls, which were often referred to as the "Niagara of the South." Some early visitors included Vice Pres. John C. Calhoun, John Howard Payne (famous for writing the song "Home! Sweet Home!"), and Joseph LeConte (a Georgia native and charter member of the Sierra Club). The arrival of the railroad in 1882 ushered in a tourist boom, and people flocked to enjoy the rugged beauty that inspired artists, writers, and naturalists. The gorge also inspired professional thrill-seekers, including J.A. St. John (also known as "Professor Leon"), who crossed the chasm on a high wire in 1886, and Karl Wallenda, who repeated the daring act in 1970.

TALLULAH GORGE. This c. 1908 view from the chasm brink, looking up the Tallulah River, shows a glimpse of Young's Bridge, located on the road from Tallulah Falls to Clayton. This bridge, like the Tallulah Falls Railroad truss bridge, was removed when the dam was built. A new, higher railroad bridge was built, but road traffic was routed across the new dam. (Walter Hunnicutt, Tallulah Falls.)

View from Chasm Brink, Tallulah Falls, Ga.

Walter Hunnicutt, Publ., Tallulah Falls, Ga.

GRAND CHASM. This 1908 postcard shows the view looking down the Grand Chasm (as the gorge was often called). The mailer of this card, which was sent to London, wrote: "I send greetings from the Switzerland of America . . . Wish we could shake hands across the chasm from my house to the house of thee." (Walter Hunnicutt, Tallulah Falls.)

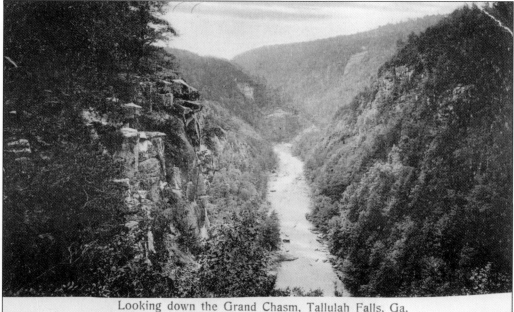

Looking down the Grand Chasm, Tallulah Falls, Ga.

Walter Hunnicutt, Publ., Tallulah Falls, Ga.

SEARCHING THE TALLULAH RIVER. The river, the falls, and the gorge were as wild at the turn of the century as they are today. This September 2, 1910, postcard tells the tale of a tragic ending: "This is a photographic picture of Tallulah River and the parties searching trying to recover the body of Miss Margery Miller of New Orleans who was drowned while in bathing Monday August 29. Her body was found this morning a mile & a half down the river at Witches head." The picture shows men with dragnets and probes searching for the missing woman. Despite the dangers of the rugged terrain and powerful river, visitors continued to be drawn to the inspirational beauty of the gorge.

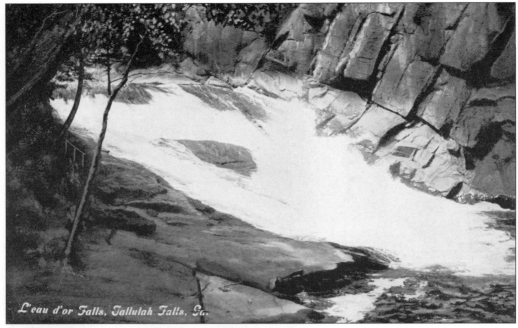

L'eau d'or Falls, Tallulah Falls, Ga.

L'EAU D'OR FALLS. Touring Tallulah Falls would not be complete without a trip to each of the main waterfalls along the river. The first is the L'Eau d'Or (or Ladore) Falls, a 50-foot waterfall that reflected sunlight in a way that gave the water a golden coloring—thus the name, which is French for "water of gold." (Blue Ridge Mountain Postcard Co., Tallulah Falls.)

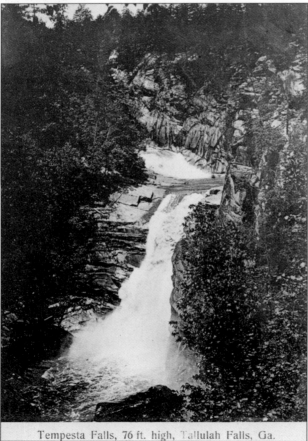

Tempesta Falls, 76 ft. high, Tallulah Falls, Ga.

TEMPESTA FALLS. The next waterfall down the river is Tempesta Falls, which drops more than 75 feet into a sparkling pool of water. The Cliff House built an observation tower from which visitors could safely view the falls. (Walter Hunnicutt, Tallulah Falls.)

HURRICANE FALLS. What a ruckus this thunderous 91-foot waterfall must have made before the dam on the Tallulah River slowed the water to a fraction of its natural flowing speed. A staircase now leads down into the gorge to a suspension bridge that overlooks Hurricane Falls. Several times a year, Georgia Power conducts high-volume water releases to the delight of visitors. (Walter Hunnicutt, Tallulah Falls.)

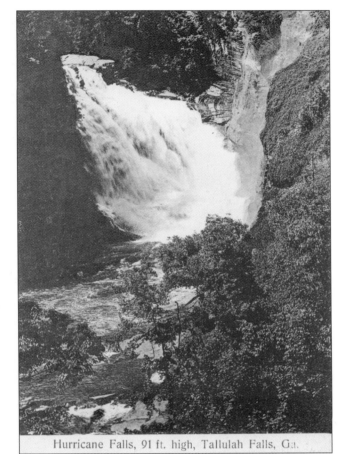

Hurricane Falls, 91 ft. high, Tallulah Falls, Ga.

OCEANA FALLS. After Hurricane Falls, the next waterfall is only about half as high. Oceana Falls is just 45 feet high but very broad. The water slides into the pool at the bottom, causing whitecap waves that reminded visitors of the ocean.

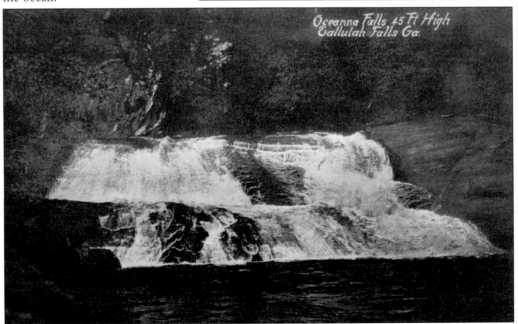

Oceanna Falls 45 Ft High
Tallulah Falls Ga.

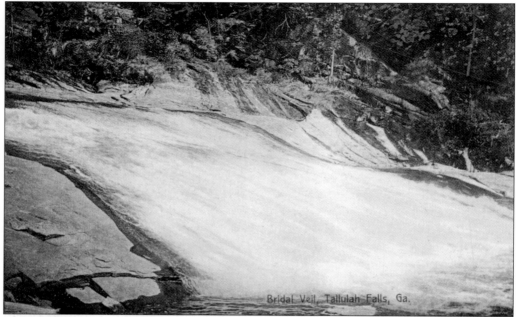

Bridal Veil, Tallulah Falls, Ga.

BRIDAL VEIL FALLS. Bridal Veil Falls, at only 37 feet high, sort of flows over its rock base more than falls. The flow creates thin sheets of water that resemble the veil of a bride. (F.W. Frye, Tallulah Falls.)

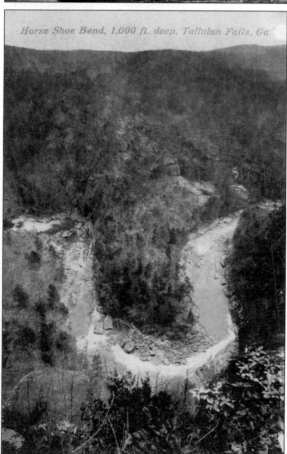

Horse Shoe Bend, 1,000 ft. deep, Tallulah Falls, Ga.

HORSE SHOE BEND. This c. 1907 postcard shows the Horse Shoe Bend, located over 1,000 feet down in the bottom of the gorge. Here, the Tallulah River makes a switchback that, when viewed from this angle, looks like a horseshoe. Horse Shoe Bend is located between Bridal Veil Falls and Sweet Sixteen Falls.

SWEET SIXTEEN FALLS. One had to follow the river around Horse Shoe Bend in order to get to Sweet Sixteen Falls. Because it was so far from the lodges, it was the least visited and photographed of the waterfalls. The sender of this 1910 postcard wrote: "Not very high, but very graceful and with a beautiful setting." (Blue Ridge Mountain Postcard Co., Tallulah Falls.)

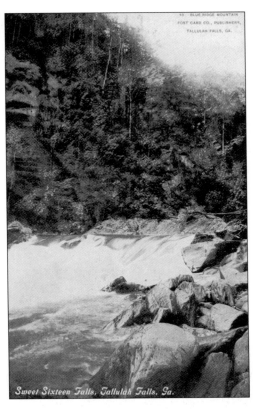

Sweet Sixteen Falls, Tallulah Falls, Ga.

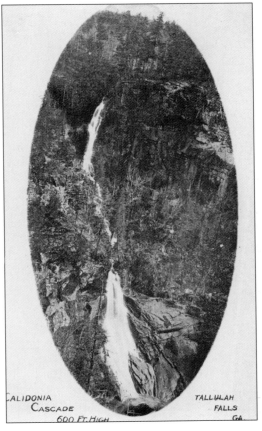

CALIDONIA CASCADE 600 FT. HIGH TALLULAH FALLS GA.

CALIDONIA CASCADE. The most famous of the waterfalls were those created by the Tallulah River. However, there were many feeder streams that also created falls. Calidonia Cascade, which fell some 600 feet, was one such feeder fall. (Commercial Chrome.)

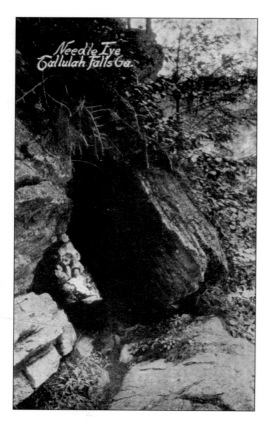

NEEDLE EYE. Another favorite for photographers who ventured into the gorge was the Needle Eye. These stacked rocks had a small opening through which one could take a picture of someone on the other side. This picture shows a woman through the "needle eye" hole. (Commercial Chrome.)

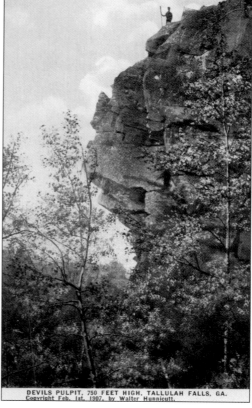

DEVIL'S PULPIT. This rock outcropping was another popular spot for tourist pictures. This 1907 picture, taken by Walter Hunnicutt from the bottom of the gorge, shows the 750-foot Devils Pulpit with a hiker posed at the top. (Walter Hunnicutt, Tallulah Falls.)

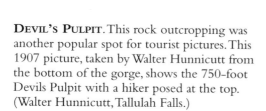

DEVILS PULPIT, 750 FEET HIGH, TALLULAH FALLS, GA.
Copyright Feb. 1st, 1907, by Walter Hunnicutt.

ANGELINA ROCK. This c. 1910 postcard shows Angelina Rock and the Grand Chasm. This rock formation was not a frequent subject of photography, but was captured by Walter Hunnicutt. The face of Angelina is not as pronounced as the Witch's Head formation, nor is it as easily viewed. (Walter Hunnicutt, Tallulah Falls.)

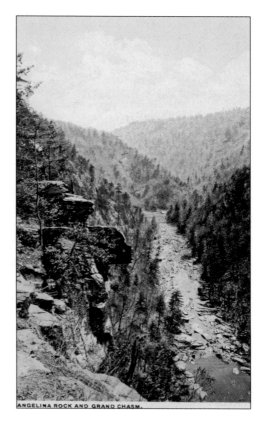

ANGELINA ROCK AND GRAND CHASM.

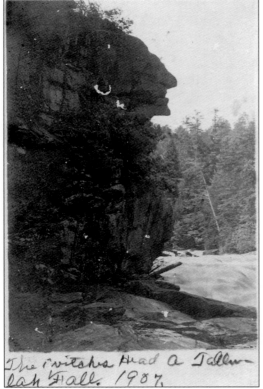

The witchs Head a Tallu-lah Fall. 1907.

WITCH'S HEAD. This is one of the most photographed rock formations in Tallulah Gorge. Looking at it from just the right angle, one can make out the "witch's" nose, mouth, and chin. To capture this c. 1907 image, the photographer had to hike down into the gorge—not an easy feat in the dress of the era.

COUNCIL ROCKS. Before white settlers arrived in northeast Georgia, the Cherokee people inhabited the area, building communities and living off the land. The Cherokee around Tallulah Falls held their council meetings on these rocks. Legend has it that this is where the white hunter was sentenced to be thrown off Lovers' Leap.

ENTRANCE TO LOVERS' LEAP. This c. 1950s postcard shows the entrance to the trail leading to the Lovers' Leap overlook. Legend has it that a young Cherokee maiden named Tallulah was so devastated by the chief throwing a white hunter off the cliff that she immediately jumped after him. (W.M. Cline Company, Chattanooga.)

LOVERS' LEAP LOOKOUT. This c. 1940s real-photo postcard shows several people at the Lovers' Leap Lookout. A rail fence was constructed around the edge to keep visitors from accidently falling 900 feet into the gorge below. From this vantage point, one can look across toward the present-day location of the Jane Hurt Yarn Interpretive Center. (W.M. Cline Company, Chattanooga.)

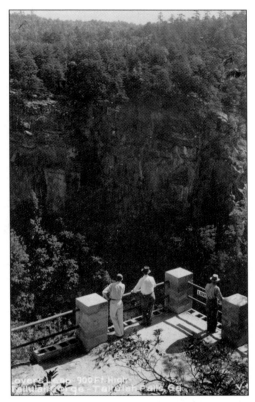

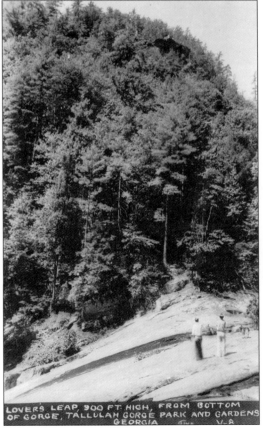

LOOKING UP AT LOVERS' LEAP. This c. 1940s real-photo postcard shows the height of Lovers' Leap. The picture was taken from 900 feet below at the bottom of the gorge. The men and dog in the picture offer a sense of just how far the overlook is from the rocky bottom. (W.M. Cline Company, Chattanooga.)

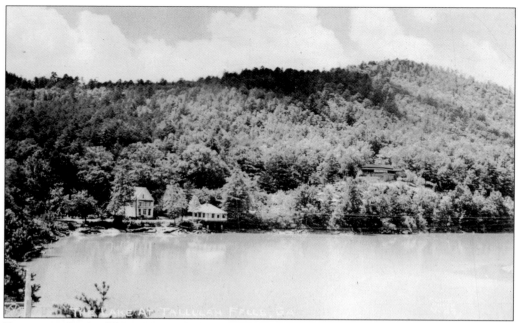

TALLULAH LAKE. This 1940s real–photo postcard shows several houses on the shore opposite the dam. After the dam was built, people quickly started building both summer and permanent homes along the lakefront. Tallulah Lake is the smallest Georgia Power reservoir in the county, encompassing 63 acres with 3.6 miles of shoreline. (W.M. Cline Company, Chattanooga.)

TALLULAH GORGE TRAIL. This 1940s postcard shows the trail through the Tallulah Gorge Park and Gardens. Two women are walking along the trail that led to Lovers' Leap and Engagement Rock. At left is a sign pointing to the Blue Ribbon Falls, which was a waterfall created by a feeder creek. (W.M. Cline Company, Chattanooga.)

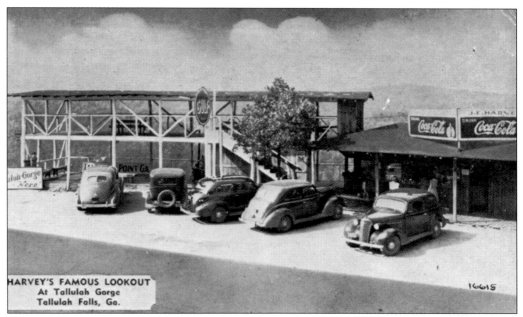

HARVEY'S FAMOUS LOOKOUT. Harvey's was a great roadside place to stop and take in the magnificent view of the gorge below. This 1949 postcard shows the store where visitors could buy souvenirs and snacks and the two-story viewing platform that was perfect for taking pictures. Harvey's (now called the Tallulah Point Overlook) is still standing and is located on the Scenic Loop. (Henry H. Ahrens, Charlotte.)

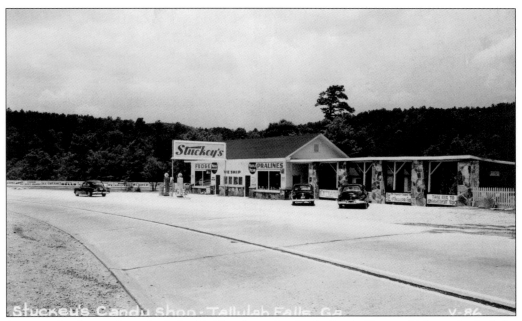

STUCKEY'S. Across from the Lakeside Hotel was Stuckey's Candy Shop, which overlooked the gorge. From 1950 until 1981, the gas station and candy shop chain store beckoned visitors with its pecan rolls, pralines, and fudge. The shop was also the entrance to a hiking trail leading to Engagement Rock. (W.M. Cline Company, Chattanooga.)

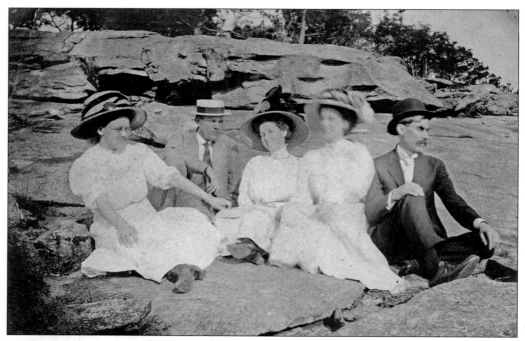

POSING PARTY. This 1909 photograph shows a group of five (a sixth person was taking the picture) posed on the rocks at the bottom of the gorge. The message on the card is interesting: "Our party the old maid did not get to go to because she did not have a beaux, we miss her just the same."

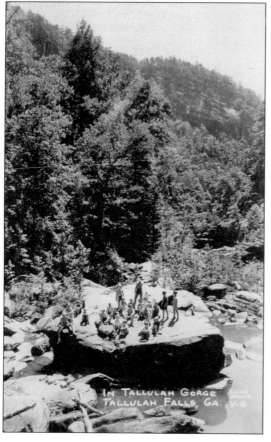

GROUP PHOTOGRAPH. On April 8, 1941, the sender of this postcard wrote, "On our first trip after getting to Loyles." Close to two dozen boys are resting on a huge boulder in the bottom of the gorge. (W.M. Cline Company, Chattanooga.)

ANOTHER VIEW OF WITCH'S HEAD. Seen from a different angle, Witch's Head loses the sharp "nose and mouth" that give the rock outcropping its name. In 1946, the sender of the postcard wrote, "We were at this place today—it's very wonderful." (W.M. Cline Company, Chattanooga.)

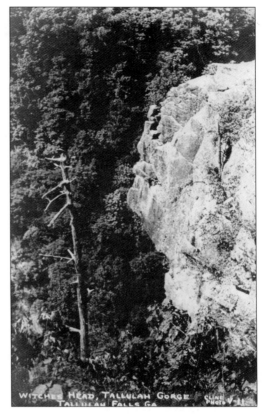

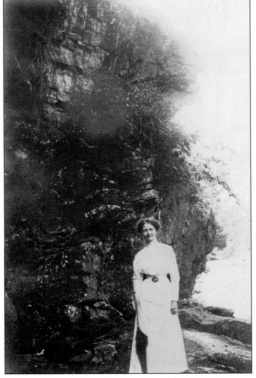

BENEATH THE WITCH'S HEAD. This c. 1910 photograph features a woman in a white Victorian dress posing with an umbrella in front of the Witch's Head rock formation. Despite the rugged hike down into the gorge and back out again, the men and women in photographs from this era always appear sharply dressed.

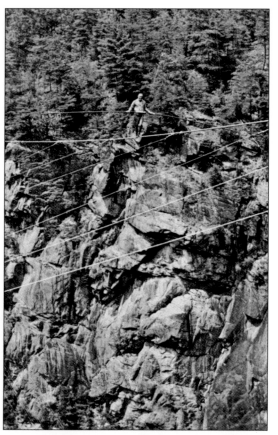

KARL WALLENDA WALKS ACROSS THE GORGE. In 1970, Karl Wallenda drew an estimated 35,000 to 50,000 spectators to watch him cross the Tallulah Falls Gorge. A cable less than two inches in diameter was strung 1,100 feet across the gorge. As onlookers watched in awe and fear, "The Great Wallenda" walked the high wire across the 750-foot-deep gorge, stopping twice to stand on his head. (Photograph by Dozier Mobley, Atlanta.)

GREAT WALLENDA WALK. Karl Wallenda was 65 years old when he made the daring high-wire walk across the gorge. These two tickets—one adult and one child—for the event state: "Proceeds will be used to build an Amphitheater. Donation portion is tax deductible [sic]." The Tallulah Falls Amphitheater still hosts musical and theatrical events.

Nine

Damming the Tallulah River

The start of the 20th century saw a huge increase in the need for electrical power for the growing metropolitan area of Atlanta. To answer this need, the Georgia Railway and Power Company (now Georgia Power) looked to the northeast Georgia mountains and the Tallulah River as a source of hydroelectric power generation. Engineers determined that the river, flowing from the headwaters above the town of Burton to Tallulah Falls, was perfect for building a series of dams and power plants. The plans were met with opposition by Helen Dortch Longstreet, who launched one of the first conservation movements in Georgia. Longstreet lost the fight to save the river's mighty flow through Tallulah Gorge, and the first of four dams was built in Rabun County in 1911.

The four dams in Rabun County are the Tallulah Falls Dam, Mathis Dam, Nacoochee Dam, and Burton Dam. The lakes that resulted from these dams are Tallulah Lake, Lake Rabun, Lake Seed, and Lake Burton. Together, these lakes formed over 100 miles of shoreline for lakeside residential and recreational development.

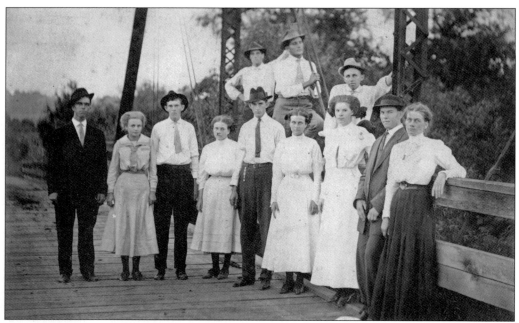

TALLULAH RIVER BRIDGE, BURTON. Prior to the Georgia Railway and Power Company damming the Tallulah River, the town of Burton was a thriving community that bordered both sides of the river; a bridge connected the two sides. A group of young people gathered on the bridge in this c. 1907 real-photo postcard.

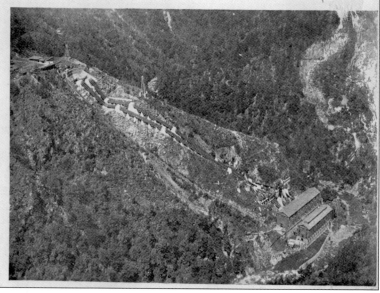

Tallulah Falls Power House Seen From The Air

THIS plant of the Georgia Railway & Power Co. is equipped with six waterwheels of 18,000 horsepower each, fed by giant penstocks that extend from the surge tank on top of the hill 608 feet down into the gorge. The surge tank is connected with lake Tallulah by a tunnel 6,666 feet long cut through solid rock. An incline railway runs to the power house.

POWERHOUSE, TALLULAH FALLS. The card says: "This plant . . . is equipped with six waterwheels of 18,000 horsepower each, fed by giant penstocks that extend from the surge tank on top of the hill 608 feet down into the gorge. The surge tank is connected with Lake Tallulah by a tunnel 6,666 feet long cut through solid rock. An incline railway runs to the power house." (Georgia Railway and Power Co.)

The Tallulah Falls Dam, at Tallulah Falls, Ga.

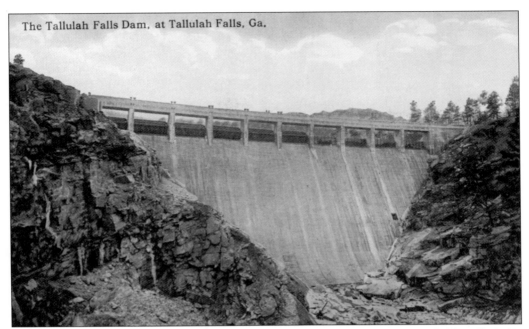

DAM, TALLULAH FALLS. This postcard shows the newly constructed dam at Tallulah Falls. Prior to the building of the dam, water from the Tallulah River crashed over the rocks, creating the two-mile gorge. The sound of thundering water was reportedly heard from miles away. (Curt Teich Company, Chicago.)

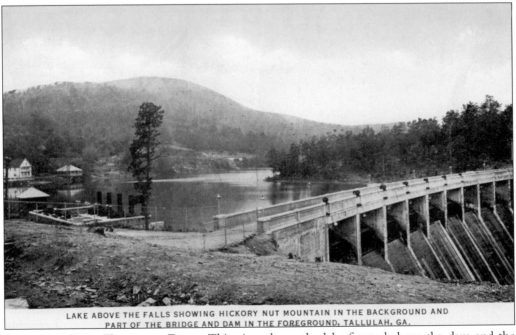

LAKE ABOVE THE FALLS SHOWING HICKORY NUT MOUNTAIN IN THE BACKGROUND AND PART OF THE BRIDGE AND DAM IN THE FOREGROUND, TALLULAH, GA.

LAKE AND DAM, TALLULAH FALLS. This view shows the lake formed above the dam and the bridge crossing. In the background is Hickory Nut Mountain and several lakeside homes. The writing on the back of the postcard reads, "This is a very beautiful spot and the picture does not do it justice." (Curt Teich Company, Chicago.)

SWITCH ROOM, TALLULAH FALLS.
This postcard offers a great view of the interior of the high-tension switch room located in the switch house. In order to make them as fireproof as possible, the powerhouse and switch house were constructed of steel, concrete, and brick. (Commercial Chrome.)

ANOTHER VIEW OF THE POWERHOUSE, TALLULAH FALLS. Georgia Railway and Power Company built this huge powerhouse and switch house below the dam. This picture was taken near the end of the construction, as evidenced by the debris around the building and the cranes still on site. Most of the electricity generated here was used to power the growing city of Atlanta.

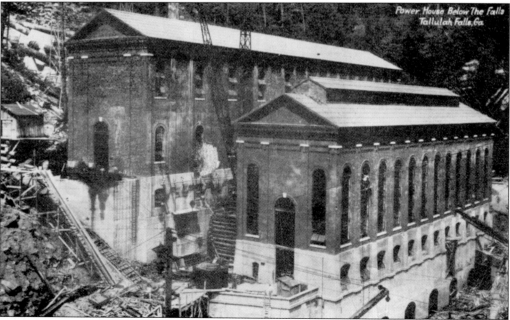

PENSTOCKS, TALLULAH FALLS. Penstocks are huge pipes used to convey the water from the forebay to the powerhouse. These six massive steel penstocks run 608 feet down into the gorge to the six waterwheels that turn the generators to produce electricity, which is then conducted to the transformers in the switch house. (Commercial Chrome.)

INCLINE RAILWAY, TALLULAH FALLS. With the powerhouse located so far down in the gorge, construction workers needed safe, reliable transportation to get to and from the site, and a cable-car incline railroad was built to carry men and materials. This railway is still the only way to get from the top of the dam to the powerhouse. (Curt Teich Company, Chicago.)

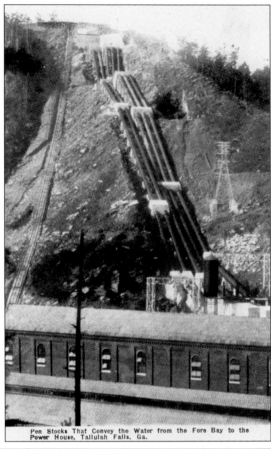

Pen Stocks That Convey the Water from the Fore Bay to the Power House, Tallulah Falls, Ga.

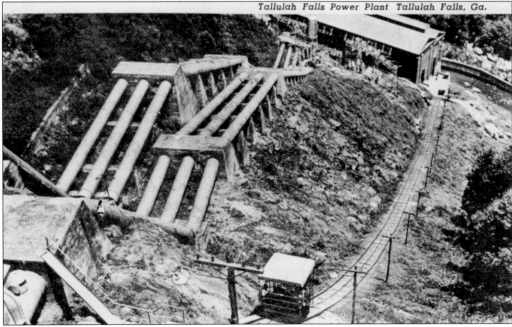

Tallulah Falls Power Plant Tallulah Falls, Ga.

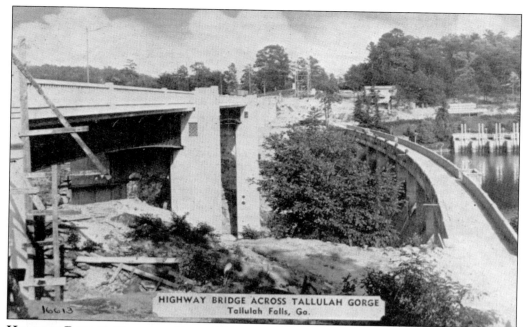

HIGHWAY BRIDGE, TALLULAH FALLS. This 1940s postcard shows the nearly completed highway bridge across the Tallulah Gorge; some of the construction debris is visible at left. Before the bridge, all traffic went over the top of the dam, which only allowed travel to go one way at a time. (Henry H. Ahrens, Charlotte.)

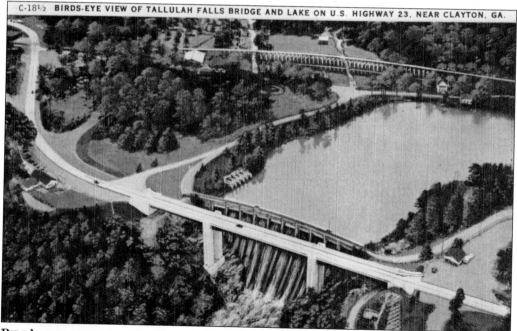

BIRD'S-EYE VIEW OF THE BRIDGE, TALLULAH FALLS. This 1940s card gives the viewer an opportunity to grasp an overview of the area around the lake. The Stuckey's building is at left, at one end of the new bridge; some houses are visible on the lakeshore; and the viewer gets a glimpse of the town and the railroad trestle near the top. (Asheville Post Card Co., Asheville.)

118

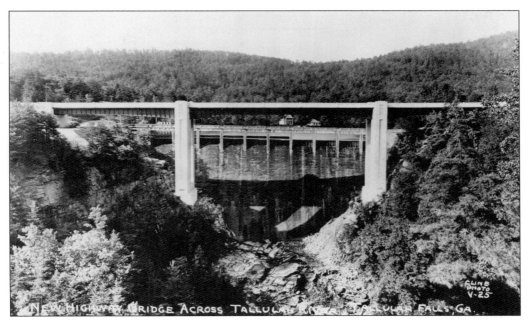

HIGHWAY BRIDGE, TALLULAH FALLS. This real-photo postcard, postmarked 1946, shows the new highway bridge in front of the dam. This angle offers the interesting sight of two houses across the lake, which are barely visible between the bridge and the dam. (W.M. Cline Company, Chattanooga.)

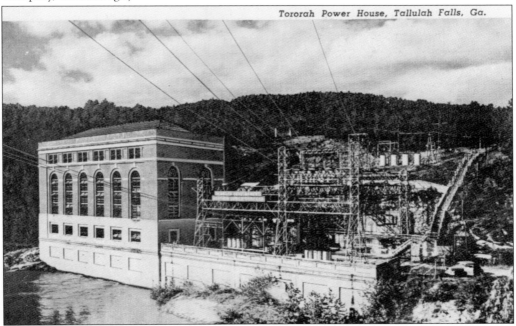

Tororah Power House, Tallulah Falls, Ga.

TERRORA POWER HOUSE, TALLULAH FALLS. The Terrora Power House, put in operation in 1925, was built about three miles upriver from the Tallulah Falls plant—between the Tallulah Falls Dam and the Mathis Dam—in order to take advantage of the change in elevation. As with the Tallulah plant, this powerhouse used penstocks to deliver water from a forebay above the Mathis Dam. (Curt Teich Company, Chicago.)

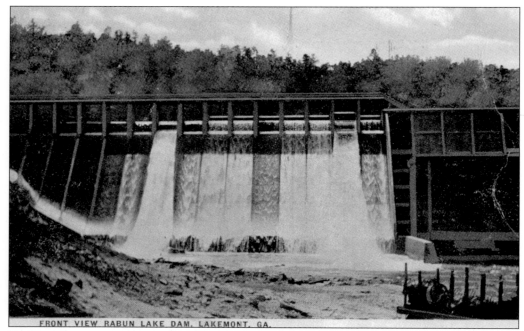

FRONT VIEW RABUN LAKE DAM, LAKEMONT, GA.

MATHIS DAM, LAKEMONT. The Mathis Dam was built in 1915 to create a water reservoir for the Tallulah Falls hydroelectric plant. Originally, there were no plans to build another power plant, but within a decade, the Terrora power plant was built; it generated 16,000 kilowatts of electricity. (Commercial Chrome.)

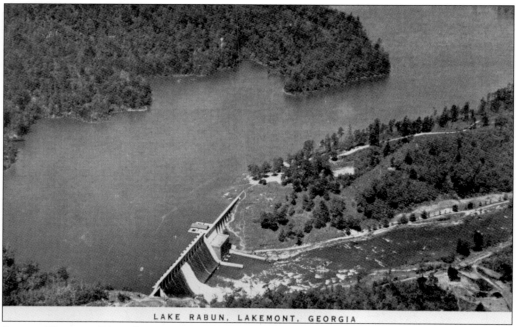

LAKE RABUN, LAKEMONT, GEORGIA

AERIAL VIEW OF LAKE RABUN, LAKEMONT. This postcard gives a clear bird's-eye view of Lake Rabun and the Mathis Dam. Lake Rabun sits at an elevation of 1,689 feet and is the second-largest lake in Rabun County. It encompasses 835 acres and has 25 miles of shoreline. There are 485 homesites along the shore. (Gray & Thompson, Chapel Hill.)

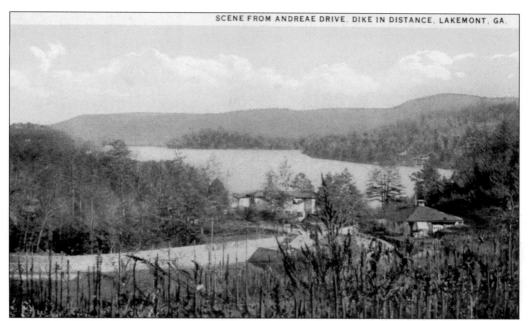

LAKE RABUN, LAKEMONT. This 1930s postcard shows the "Stone Lodge" on Andreae Drive and the dike in the distance. In 1917, Dr. George Bellinger built a log house that was called "the lodge," a sea wall, and a boathouse. In the 1930s, he sold his property to F.O. Stone, who built a chalet on the foundation of the boathouse and started calling the property "Stonehaven." (Paul Alley, Lakemont.)

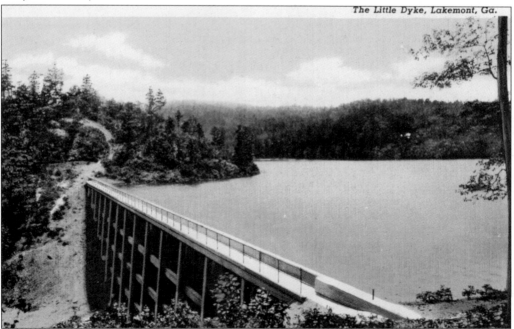

The Little Dyke, Lakemont, Ga.

LITTLE DYKE, LAKEMONT. At the time the Mathis Dam was being built, a dike was also needed to contain water in the lake where the natural topography would have allowed it to escape. The Little Dyke, seen in this 1920s postcard, now serves as the base for the Lake Rabun Association's annual Fourth of July fireworks display. (Paul Alley, Lakemont.)

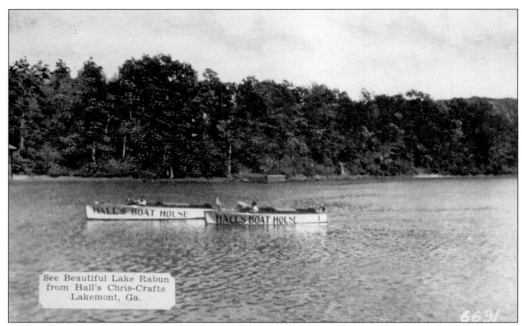

See Beautiful Lake Rabun
from Hall's Chris-Crafts
Lakemont, Ga.

HALL'S CHRIS-CRAFTS, LAKEMONT. In 1919, Guy W. Hall Sr. opened Hall's Boat House on Lake Rabun. Hall ran the boathouse until the 1940s, when his son Guy W. Hall Jr. took over the business and ran it until 1972. Hall's had a fleet of Chris-Craft boats with "Hall's Boat House" on the side. A wooden boat regatta remains an annual July Fourth weekend tradition on Lake Rabun. (Kaeser & Blair, Inc., Cincinnati.)

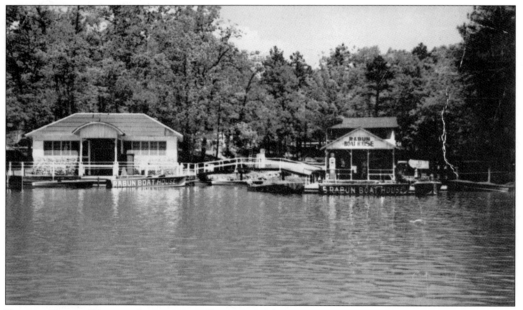

RABUN BOAT HOUSE, LAKEMONT. "Fast speed boat rides, large fleet of boats for fishing and riding. Good restaurant in connection . . . W. W. Wall Jr., prop," reads the back of this postcard. Built in 1922 by Miles Patterson, the boathouse was sold to Mr. Harvey and then to W. W. Wall. The Rabun Boat House was across from Hall's Boat House. (Henry Hahn, Banner Elk.)

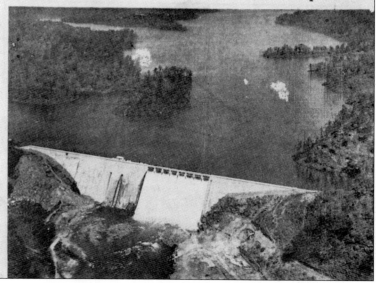

Lake Burton and Dam as seen from an Aeroplane

THIS beautiful body of water forms the largest reservoir of the Georgia Railway & Power Company. The dam is 116 feet high and forms a lake covering 2,775 acres, with a shore line of 64 miles. The lake is famous as one of the greatest fishing resorts in the South.

LAKE BURTON DAM, CLAYTON. This card reads: "This beautiful body of water forms the largest reservoir of the Georgia Railway & Power Company. The dam is 116 feet high and forms a lake covering 2,775 acres, with a shore line of 64 miles. The lake is famous as one of the greatest fishing resorts in the South." (Georgia Railway & Power Company.)

THE ROCK HOUSE AND CABINS, LAKE BURTON, CLAYTON, GA.

CABINS ON LAKE BURTON, CLAYTON. The formation of Lake Burton created a popular summer vacation spot in the northeast Georgia mountains. Summer homes, camps for children, and rental cabins flourished for decades. This 1950s postcard showing the Rock House and cabins lists the various activities available for guests: "Fishing, Swimming, Boating, Hiking." (*Clayton Tribune*, Clayton.)

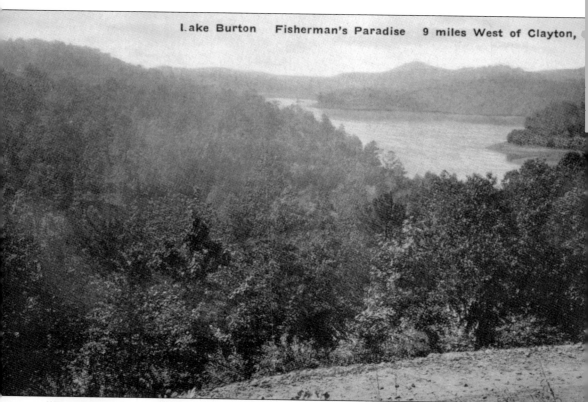

"FISHERMAN'S PARADISE," CLAYTON. Lake Burton, located nine miles west of Clayton, lures many anglers to its bountiful waters, which contain a large variety of fish, including trout, walleye, crappie, catfish, and largemouth bass. This 1950s postcard offers a glimpse of one of the many coves that branch off from the main body of the lake. (McCurdy's Drug Store, Clayton.)

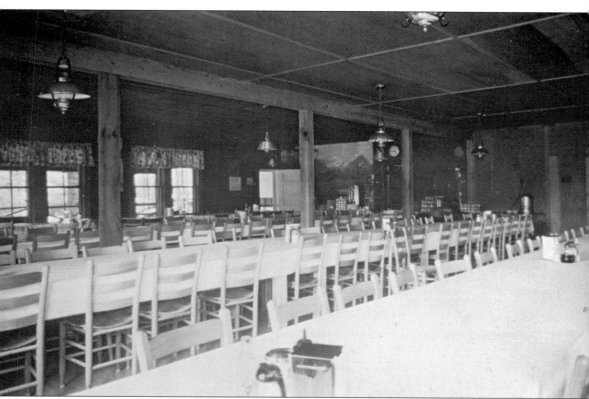

LaPrade's, Lake Burton. A land agent for the power company, John LaPrade, purchased land along the lake's shore and opened a fish camp in 1925. In the early 1930s, the fish camp was used as a staging area for the Moccasin Creek Civilian Conservation Corps camp. LaPrade's grew into a full-service marina and family-style restaurant. This postcard shows the restaurant's dining room, which was destroyed when LaPrade's burned down on May 15, 2005. The property was purchased in 2006 and now contains a marina, two restaurants, and an Adirondack-style pavilion. (Dexter Press, West Nyack, New York.)

BIBLIOGRAPHY

Boyd, Brian A. *Yesterday's Rabun*. Clayton, Georgia: Fern Creek Press, 1998.

———. *Secrets of Tallulah*. Clayton, Georgia: Fern Creek Press, 2003.

Calhoon, Margaret and Lynn Speno. *Tallulah Falls*. Charleston, SC: Arcadia Publishing, 1998

Carver, Kaye and Myra Queen, ed. *Memories of a Mountain Shortline, Commemorative Anniversary Edition*. Clayton, GA: Fern Creek Press, 2001.

Cross, L.P. *Ramblin' In Rabun*. Clayton, GA: Prater's Main Street Books, 2007.

McKay, Cuba and Archie. *A Pictorial History of Rabun County*. Virginia Beach, VA: The Donning Company Publishers, 2003

Noble, Ben Jr. and Olin Jackson. *"Take to the Hills!" Lakemont, GA: The Early Years*. Woodstock, GA: Legacy Communications, 1989.

Rabun County Georgia and Its People, Vol. 1. Clayton, GA: Rabun County Historical Society, 1992.

Reynolds, George P., and his students, ed. *Foxfire 10*. Mountain City, GA: The Foxfire Fund, Inc., 1993.

Ritchie, Andrew Jackson. *Sketches of Rabun County History*. Clayton, GA: Rabun County Historical Society, 1948.

INDEX

DISCOVER THOUSANDS OF LOCAL HISTORY BOOKS
FEATURING MILLIONS OF VINTAGE IMAGES

Arcadia Publishing, the leading local history publisher in the United States, is committed to making history accessible and meaningful through publishing books that celebrate and preserve the heritage of America's people and places.

Find more books like this at
www.arcadiapublishing.com

Search for your hometown history, your old stomping grounds, and even your favorite sports team.

Consistent with our mission to preserve history on a local level, this book was printed in South Carolina on American-made paper and manufactured entirely in the United States. Products carrying the accredited Forest Stewardship Council (FSC) label are printed on 100 percent FSC-certified paper.

MADE IN THE